IMAGES
of America

THE LOST VILLAGES
OF SCITUATE

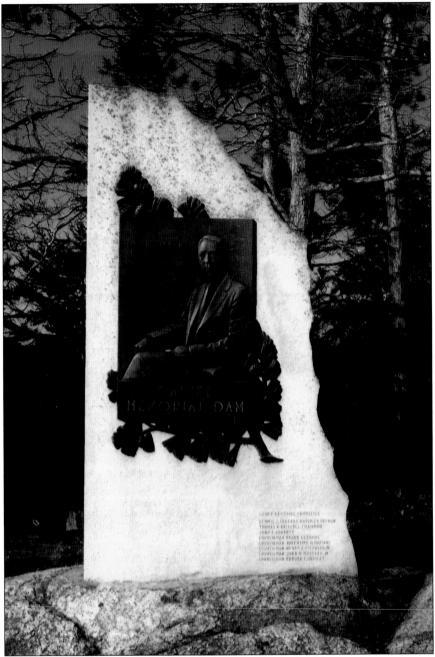

This plaque reads, "Dedicated to the memory of the late Hon. Joseph H. Gainer mayor of the City of Providence 1913–1927 during whose administration this reservoir and water supply system was planned and constructed Gainer Memorial Dam." (Author's collection.)

On the cover: This valley is the location chosen to build the dam to create the Scituate Reservoir. The land is being cleared and construction of the dam is underway. The village of Kent, presently 87 feet under water, would be just to the left of the picture. (Courtesy of Providence Water Supply archives.)

IMAGES
of America

THE LOST VILLAGES
OF SCITUATE

Raymond A. Wolf

ARCADIA
PUBLISHING

Published by Arcadia Publishing
Charleston SC, Chicago IL, Portsmouth NH, San Francisco CA

Printed in the United States of America

Library of Congress Control Number: 2009921325

For all general information contact Arcadia Publishing at:
Telephone 843-853-2070
Fax 843-853-0044
E-mail sales@arcadiapublishing.com
For customer service and orders:
Toll-Free 1-888-313-2665

Visit us on the Internet at www.arcadiapublishing.com

To my mom, Helen O. Larson,
who was born and lived in the lost village of Rockland.

CONTENTS

ACKNOWLEDGMENTS

The driving force behind this book becoming a reality is the memory of my mom. She lived in one of the villages that were consumed by the building of the Scituate Reservoir. She told many stories of growing up there as a child. I want to thank Karen Sprague for conducting a candlelight tour of the new Rockland Cemetery and introducing me to Shirley Arnold, a Scituate historian. I want to give Shirley credit for encouraging me to contact the City of Providence Water Supply Board to obtain photographs of the village of Rockland. I also appreciate her allowing me to include pictures from her collection. I want to give Richard Blodgett from the City of Providence Water Supply Board a huge thank-you. He gave many hours of his time on the phone and in person. The two of us dug through archives of maps and photographs on numerous occasions. He even met me one morning at 8:00 a.m. at the site of my mother's homestead. Without his cheerful help, you would not be reading this book. Thomas D'Agostino, a fellow author who also attended the candlelight tour, was very inspirational and supportive. I wish to thank my friends Joe and Jenn Carnevale and Bill and Joyce Bartlett, along with family Jake and Mona Cardente for their tireless effort proofreading and being supportive and enthused of my endeavor. Thanks to my daughter, Ashlee Rae, for her patience and assistance to accompany me on the candlelight tour and numerous trips to Rockland and other locations. To Ramona, my wife and partner, for understanding and being patient with my passion to complete this book, I love you. Last but by no means least, I want to recognize Hilary Zusman, my assistant editor at Arcadia Publishing, for being so helpful. From my first e-mail inquiry, to the book you hold in your hands, she never tired of my questions and was always encouraging and there for me; a great big thank-you goes to her.

Unless otherwise noted, all images appear courtesy of the City of Providence Water Supply Board archives.

INTRODUCTION

It is believed John Mathewson was the first white man to settle in what is now Scituate in 1710. Scituate was set off from the town of Providence as a district township in 1731. The 1810 census recorded 2,568 inhabitants. The five lost villages in the town of Scituate were Rockland, Ashland, South Scituate, Richmond, and Kent. They were established in the early 19th century, just after 1800. Mills were being built on the north branch of the Pawtuxet River and two major tributaries, the Ponaganset and Moswansicut Rivers also the Westconnaug River, which is a branch of the Ponaganset River. The mill owners would then construct duplexes to house the mill workers. In time, they built churches, a post office, school, stores, and eventually old Native American trails became roads. The 1880 census records the population had grown to 3,810. In June 1901, the Providence and Danielson (Electric) Railway Company opened service to Scituate and built a powerhouse in Rockland to operate its trolley system running between the villages and Providence.

In the meantime, Providence was growing and prospering. In January 1913, the city council appointed a water supply board to locate another source of water for the city. The search led the board to Scituate's numerous waterways. In 1915, the general assembly created a new water supply board and gave it extensive powers. This led to the condemnation, by eminent domain, of 14,800 acres of land and buildings in the reservoir and watershed area. The first contract for the project was awarded in 1915, followed by condemnation of 23.1 square miles of land beginning in December 1916. January 1917 saw the first contract awarded for the excavating and construction of the dam. The contract to build the filtration plant was awarded in 1924.

On November 10, 1925, the reservoir was complete and began storing 41 billion gallons of water behind the 3,200-foot-long dam that hovered 100 feet above where once stood the thriving village of Kent, now drowned by fate. Almost a year later, on September 30, 1926, at 9:45 a.m., the $21 million project started supplying the city of Providence and surrounding areas with a new supply of freshwater. The honor of turning on the last set of filters at the purification plant was reserved for Ald. B. Thomas Potter, the former chairman of the water supply board.

There were 1,195 buildings razed, of which there were 375 homes, 233 barns, 7 schools, 6 churches, 11 icehouses, 5 halls, post offices, taverns, general stores, blacksmith and wheelwright shops, cider mills, 2 fire stations, 30 diary farms, and the Providence and Danielson Railway. There were approximately 1,500 graves exhumed and moved to other sites; 1,080 were relocated to the newly created Rockland Cemetery in Clayville. Through the heartache and tears of many people over 80 years ago, today over 60 percent of Rhode Islanders enjoy some of the purest drinking water in the country. The Scituate Reservoir is now operated by the Providence Water Supply Board.

Helen O. Larson was born on October 24, 1910, in the village of Rockland. She lived in the small New England village until she was 13, when she and her family were forced to move. Helen witnessed the destruction of her village and the heartache of her neighbors moving away one at a time. Many years later, she wrote the poem below expressing how she felt about the taking of her village. When Helen passed away in 2005, well into her 94th year, she had composed 1,700 poems. She often said, "I put the pen to the paper and the ink begins to flow. I could never write like this with only an eighth-grade education. People always say it is a gift I have."

The Scituate Reservoir

The land was condemned
the people were told
Everyone felt sorry
for the folks who were old
People in Providence
needed clean water to drink
The city bought five villages
people had to sign with pen and ink

Some folks were born there
some lived there for years
They just couldn't seem
to shake off their tears
When a lawyer told them
the city had condemned the land
They were bewildered
and couldn't understand

To the scene of my childhood
I returned one day
I had a lump in my throat
it was difficult to keep the tears away
As I observed each loving place
it didn't look the same
Tears filled my eyes
as I passed the old country lane

I saw the road that led to a house
where we children used to play
We spent many happy hours there
every rainy day

I saw the root cellar
still in its place
And once again
tears rolled down my face

Going to the old church
I walked through snow and rain
Oh! If I could only
relive those days again
I saw the remains of the mill
that stood in the center of town
I can't describe the heartache
when they tore it down

If I close my eyes
I can see them today
One by one each family
moving away
Friends and neighbors
moved far apart
Another family moved
another broken heart

I go back now and then
the foundations are still there
I turn around and walk away
in my heart a silent prayer
We all know the reservoir
has been there many years
And I still believe it was filled
with the peoples' tears.

One

THE LOST VILLAGE
OF ROCKLAND

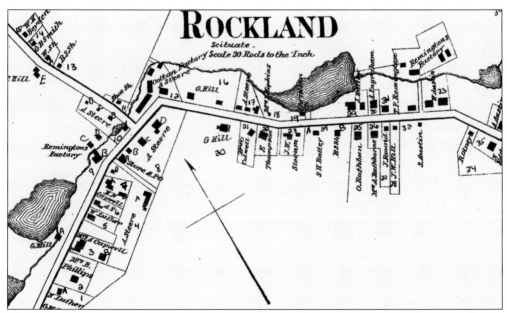

This 1870 map illustrates how large the village of Rockland was. It sustained three mills and even had two barbershops. To the west was the road leading to Clayville, the road to the north led to Ponaganset, and the road heading southeast out of the village traveled to Richmond and then on to Kent Village. The New Rockland Cemetery was established just outside of the village on the road to Clayville where 1,080 graves were transplanted as a final resting place.

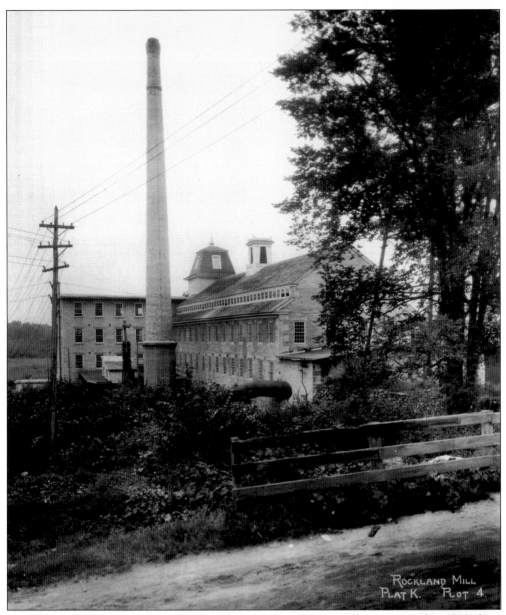

ROCKLAND MILL
PLAT K. PLOT 4.

The village of Rockland was established when the first of three mills was erected in 1812 along the Westconnaug River, a branch of the Ponaganset River. This is the rear view of the Rockland Mill, the first one built. It was built for the manufacture of cotton yarn by Joshua Smith, Frank Hill, and several other men. It burned down in 1854 but was rebuilt in 1856 and leased to Alanson Steere, who purchased the property in 1865. He made extensive additions to the mill in 1875. The road in the foreground is the Rockland to Ponaganset Road. It was later renamed and is known today as Plainfield Pike. To the right of the photograph would be the intersection of the Rockland to Richmond Road, which travels in front of the mill as shown on the facing page.

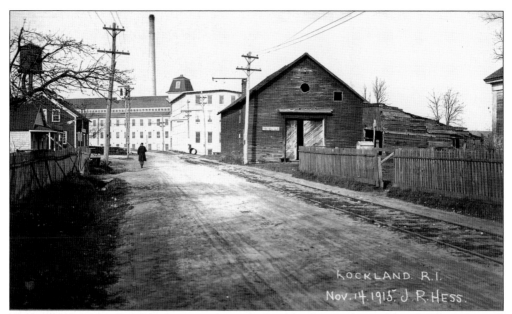

This is the Rockland Mill looking north on the Rockland to Richmond Road. When the mill was destroyed, the new road was constructed to go straight instead of curving to the left. Now the road actually goes right over where part of the mill once stood. The road is now recorded as Tunk Hill Road, which ends just past the end of the mill at the now Plainfield Pike. Below is the top floor of the main mill building at the complex. It sits totally stripped of its old and deafening machinery, quietly awaiting the appearance of the demolition crew. John R. Hess was hired to photograph all the buildings that had been condemned. Due to their foresight, this book is able to exist.

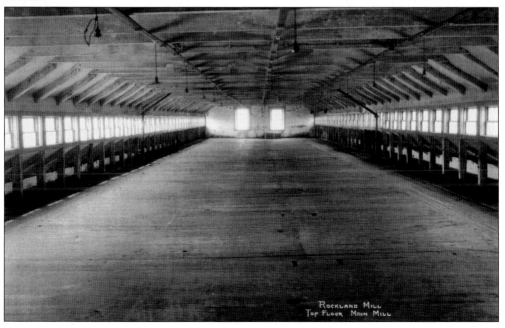

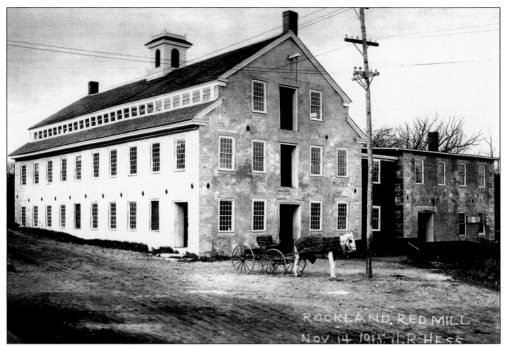

The second mill at Rockland was known for a long time as Remington's Mill but later became the Red Mill. It was constructed by Peter B. and Peleg C. Remington about 1815 to manufacture cotton yarn. It was located on the Westconnaug River above the Rockland Mill. It burned in 1840 and was rebuilt. Alanson Steere also purchased this property in 1865 and made extensive additions in 1871 and 1891. The Red Mill built duplexes for its workers as did most of the mills in this era. The following verse is from "The Old Red Mill" by Helen O. Larson: "The old Red Mill in Rockland now is used no more / We hear no more footsteps walk across the floor." These photograph was taken on Sunday, November 14, 1915.

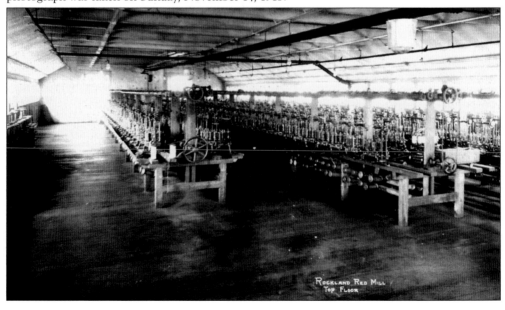

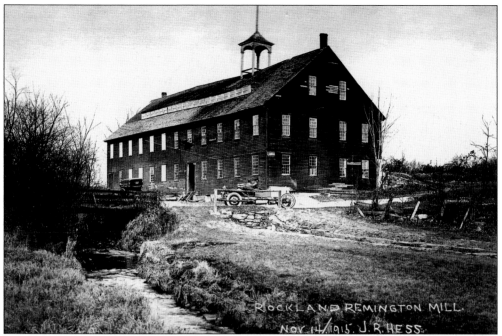

ROCKLAND REMINGTON MILL.
NOV 14/1915. J.R.HESS.

This photograph, taken on November 14, 1915, shows the third mill. Thomas Remington erected it in 1832, and it was known as the Remington Mill. In 1845, it was leased to Barden and Manchester for 10 years. At the end of the lease, Remington resumed the manufacture of cotton cloth until the Civil War broke out, and he stopped manufacturing entirely. Theresa B. Joslin acquired the mill on December 1, 1906. Even though it was condemned in 1916 and was to be demolished, she had it totally reconstructed in 1918 as the photograph below shows on November 24, 1918.

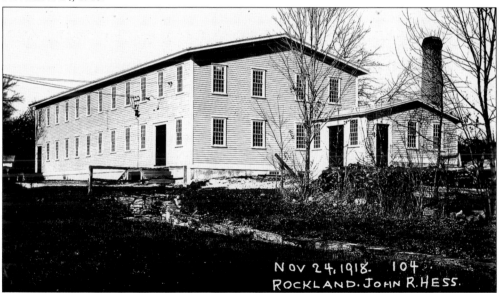

NOV 24, 1918. 104
ROCKLAND. JOHN R. HESS.

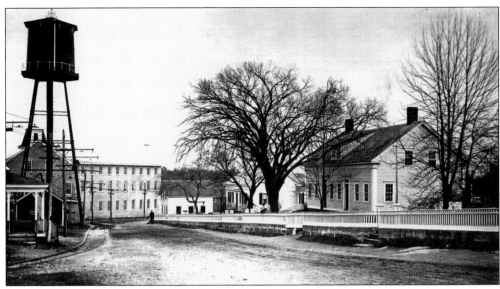

This water tower was added to the Rockland Mill in 1905 along with sprinklers. In 1906, a hydroelectric plant was added. The length of time it took John R. Hess to drive from the location of the photograph on page 11 to this location gave the gentleman walking time to round the corner. It is good to see that he is walking facing traffic. The boy on the fence has no interest in Hess and his camera, as he is facing the house.

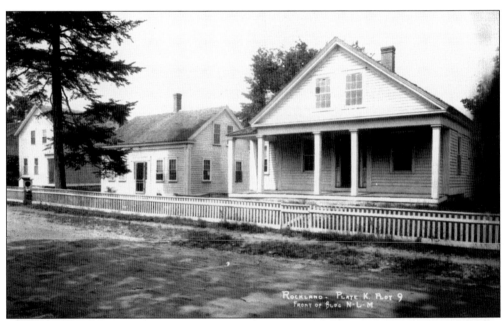

The single-family homes on this page were located directly across from the Rockland Mill on the Rockland to Richmond Road. The following verse is from "Days of Destruction" by Helen O. Larson: "They were quiet New England villages, all the houses were painted white / And as you drove by them, they were a beautiful site." Most likely the well in front of this row of houses was shared by all. The road at this point is approaching the Rockland to Ponaganset Road, now Plainfield Pike.

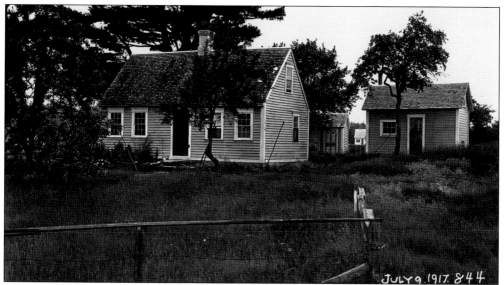

John H. and Harry M. Luther lived here at one time. Apparently from the look of things, when this photograph was taken on July 9, 1917, they had up and left some time ago. However, maybe knowing their demise, they had just given up and were buying time. They knew they would be forced to vacate their home as their neighbors had done previously.

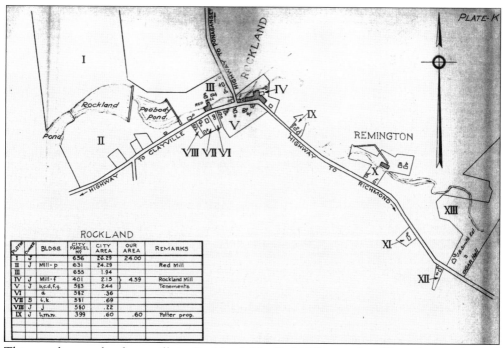

P. OTHER	Owner	BLDGS.	CITY PARCEL Nº	CITY AREA	OUR AREA	REMARKS
I	J		656	26.29	24.00	
II	J	Mill-p	651	24.29		Red Mill
III			655	1.94		
IV	J	Mill-f	401	2.15	4.59	Rockland Mill
V	J	b,c,d,f,g.	583	2.44		Tenements
VI		a.	582	.36		
VII	S	i,k.	581	.69		
VIII	J	j	580	.22		
IX	J	t,m,n.	399	.60	.60	Potter prop.

This map locates the three mills in Rockland. The Red Mill is number III on the map, located on the north side of the Highway to Clayville. The Rockland Mill is number IV and is located just south of the Highway to Ponaganset on the Highway to Richmond. The Remington Mill is number X and is located further south on the Highway to Richmond on the north side.

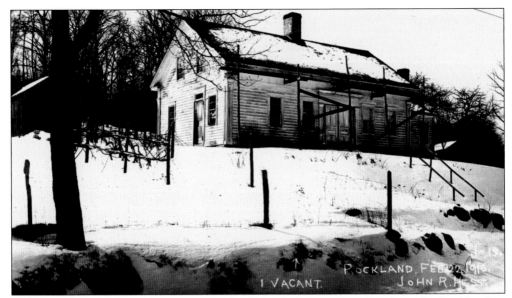

This vacant duplex was located just south of the George P. King Road on the Rockland to Richmond Road. One can sense the heartache and tears as the two neighbors packed up to go their separate ways. Now that they are gone, the building is being readied to be torn down on this cold and snow-covered day, February 20, 1916.

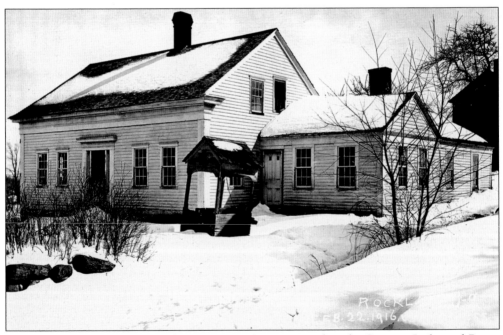

In this photograph, taken on February 22, 1916, it appears that the Scituate Light and Power Company had also packed up and deserted its property. The abandoned building knows its days are limited and silently waits for spring when it will be auctioned off, torn down, and taken away.

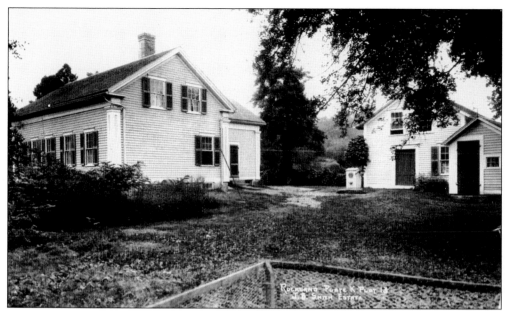

This is the well-maintained estate of J. B. Smith. It was located south of the Remington Mill on the Rockland to Richmond Road. Note the great condition of the outbuildings and the ever-present well. The villagers worked hard and really took pride in their homesteads.

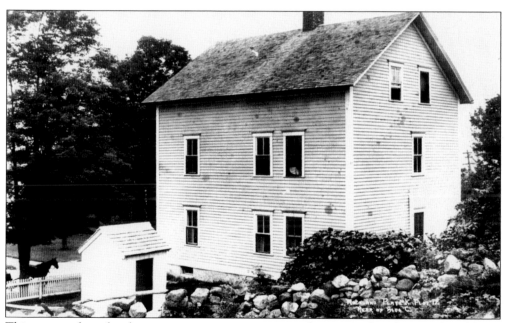

This two- to three-family tenement is waiting to meet its demise. As this photograph indicates, the horse-drawn carriage was still a viable form of transportation in the early 1900s. The good old outhouse was standard equipment to any house, as there was no inside plumbing.

This is a photograph of Alonzo King. He was born in Cranston, a busy suburb of Providence. When King became older, he decided to move to the rural country and settled in Rockland. He landed a job in the Rockland Mill and soon met a girl. Susan Taylor was her name, and she was a member of the Nipmuc Indian tribe. They fell in love and were soon married. It is not known how many children they had, but it is recorded that they had a baby girl on February 15, 1893. They named the newborn Mary O. King. When Mary grew up and married Andrew Francis, she named her only girl Helen O. Francis (born on October 24, 1910). King's age in this photograph is unknown. (Author's collection.)

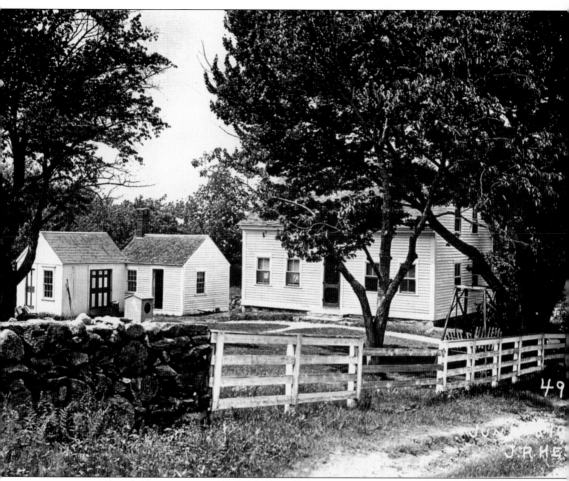

The family farm was located on the George P. King Road. Andrew and his wife, Mary O. (King) Francis, lived here with their five children, Andrew, Edward, Elmer, John, and Helen. Mary's father, Alonzo, also lived with them. Helen was one of the very last survivors that remembered the City of Providence condemning the five lost villages. The following verse is from "Days of Destruction" by Helen O. Larson: "Peoples hearts were breaking to see the beautiful villages destroyed that day / And with tears and broken hearts they packed up and moved away." As they moved away one family at a time, most never to see each other again, the day finally came when her farm was sold, and they had to move also. The family moved when she was 13 to the southern part of Scituate to a small cottage on Harrington Avenue in a village called Hope. Helen spent her remaining years there. Hope is another mill village located on the Pawtuxet River, downstream from where the dam was being built and therefore this village was spared. The barn and henhouse would be to the left of this picture.

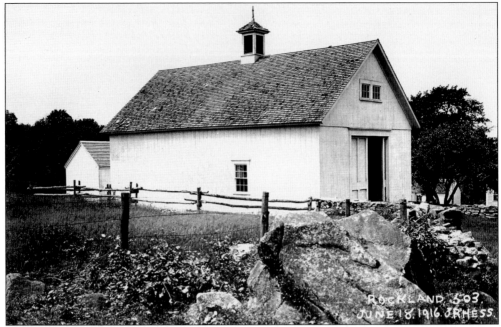

The following verse is from "My Home in Rockland" by Helen O. Larson: "There was a large white barn where we kept our Jersey cow / If I close my eyes I can see it now." From time to time, Andrew Francis would also paint a car inside to earn some extra money. Note the large rock in the foreground and how the upper left corner is cracked on June 18, 1916. The henhouse was located behind the barn. The out buildings and the house would be to the right.

This photograph was taken on June 16, 2008, from approximately the same location as the one above. After more than 90 years, the rain and ice have finally broken off that chunk of rock as it lies on the ground in the lower left of this picture. Compare the wall on the right that used to end at the barn. Mother Nature and Father Time have taken their toll. (Author's collection.)

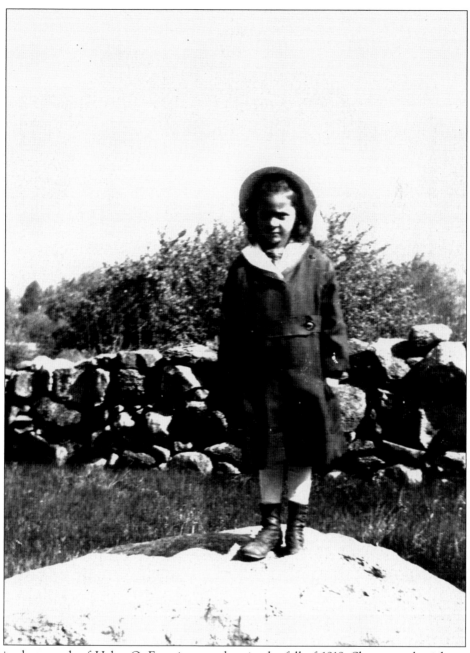

This photograph of Helen O. Francis was taken in the fall of 1918. She was only eight years old at the time. The following verse is from "Days of Destruction" by Helen O. Larson: "One day surveyors came to survey the land / we were just children, what they were doing we didn't understand." Her house would have been located directly behind the photographer taking this picture. The only things left of the old homestead are the stone foundations of the house, barn, and outbuildings. They were high on a hill located in the watershed area and therefore not flooded. The pain of losing her homestead never faded away with the passing of time. She lived by herself in the house she and her husband built in 1942 in Hope Village. Helen passed away quietly in 2005 at the age of 94. (Author's collection.)

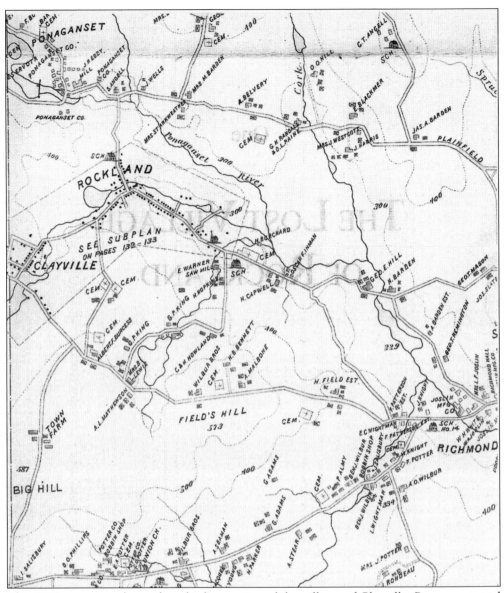

This 1895 map gives the reader a bird's-eye view of the villages of Clayville, Ponaganset, and Richmond in relationship to the village of Rockland. The Rockland School is located on the south side of the Rockland to Richmond Road near the corner of the George P. King Road. The Rockland Christian Church is on the north side of the road headed back to the village. It is obvious by the appearance of the houses lining both sides of the road that the villagers were very close knit. Not only did they live door to door, but they also worked elbow to elbow in the village mills. All of Rockland was condemned, some buildings succumbed to the rising water while others were in the watershed area, all were condemned and torn down, and the lumber was taken away. The following verse is from "Heartache in Rockland" by Helen O. Larson: "The City of Providence bought the houses, churches, mills, stores, and the school too. / All the neighbors were told they had to move, all of them not just a few."

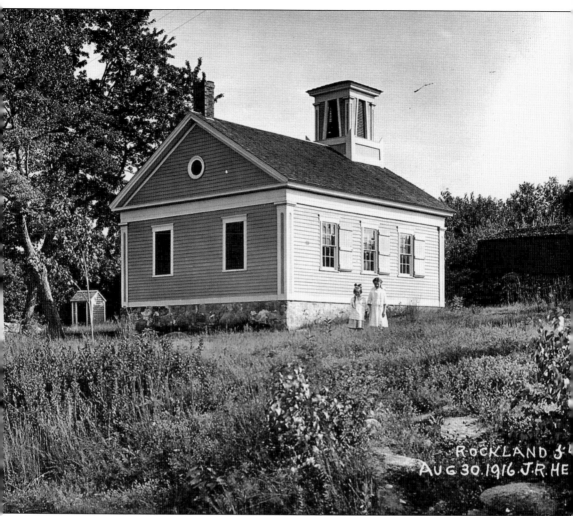

This photograph of the Rockland School was taken from the Rockland to Richmond Road on August 30, 1916. These two little girls, seen outside of their schoolhouse on this lovely Wednesday afternoon in August, were probably wondering why this man was taking a picture of their school. They may have been too young to have realized that in less than seven years, their school would be no more, even though in less than seven days they would be attending classes again. Helen O. Francis at the age of 12 in 1923 wrote the poem "The Old Schoolhouse" on the blackboard as workers were tearing it down: "It was a very sad day when we children were told / They were building a reservoir our school would be sold / A man came one day and nailed up a sign for all to see / The sign read condemned it meant heartbreak for me / It was then we were told an auctioneer would come one day / To auction off this old school house to be torn down and taken away / Then the day arrived the auction took place / The people began to bid tears rolled down my face / Going, going, gone the auctioneer cried / And on that fateful day something within me died / The old schoolhouse at Rockland now is used no more / No more children will enter through the door / I'll come back now and then to reminisce and see / But the old schoolhouse at Rockland will be just a memory."

The Rockland Christian Church was nestled between the Remington Mill Pond and the Rockland to Richmond Road just north of the George P. King Road. The following verses are from "The Old White Church" by Helen O. Larson: "If you use your imagination you can see the people walking, going humbly on their way / hustling off to the old white church to sing, to kneel, and pray. When the summer weather was fair and the windows were open wide / you could hear the congregation singing the old hymns inside." The church received $2,500 and was granted the right to use the church until the time it would be demolished. The congregation also had the option to remove the church themselves and rebuild at another location. It was a sad day for the remaining people of Rockland that witnessed the tearing down of their beloved church that many generations of their family had attended.

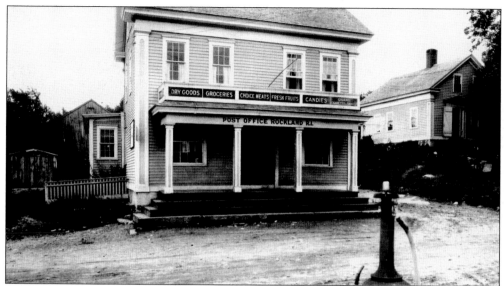

In the early 1900s in small villages, the U.S. post office would be located within the local general store. The proprietor of this Rockland store is proud to advertise that he carried dry goods, groceries, choice meats, fresh fruits, candies, and cigars, cigarettes, and tobacco. He also advertised the "Post Office Rockland R.I." He and his family lived in the house to the right. In this photograph the globe is missing from the gas pump as shown in the one below.

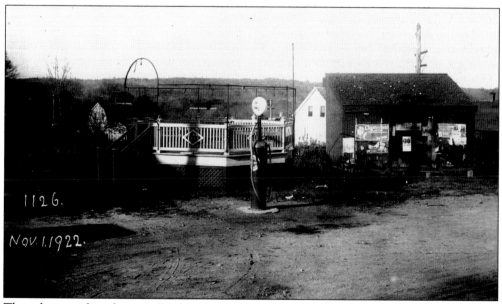

This photograph, taken on Wednesday, November 1, 1922, shows the bandstand used for speeches at the end of parades. It was located directly across the road from the store in the photograph above. There are still houses visible in the valley even though in two years it would be submerged, gone forever.

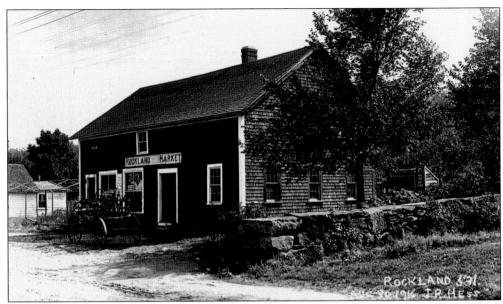

This photograph of the Rockland Market was taken on August 30, 1916, by John R. Hess. The market was owned by George E. Hill and was located on the Rockland to Richland Road near Rockland Village.

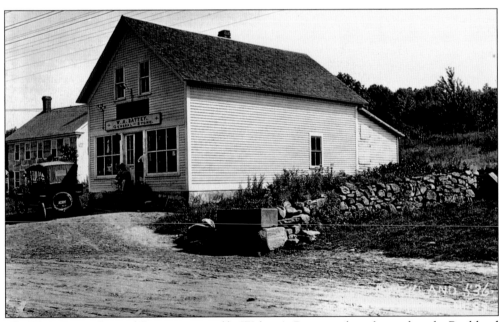

The W. A. Battey General Store was owned by Walter A. Battey and was located on the Rockland to Richmond Road near Rockland. Ella J. Rathbun lived in the house to the left of the store. The following verse is from "If I Could Go Back" by Helen O. Larson: "The old country store where our food we used to buy / The day it was demolished many people were left to cry." This photograph was taken on August 30, 1916.

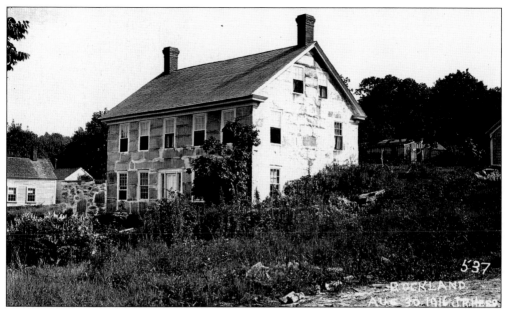

Ella J. Rathbun lived next door to Battey's general store in this beautiful stone two-story home. Her home can be seen in the photograph on the facing page behind Hess's automobile and to the left of the store. It was taken on a nice, sunny Wednesday, August 30, 1916.

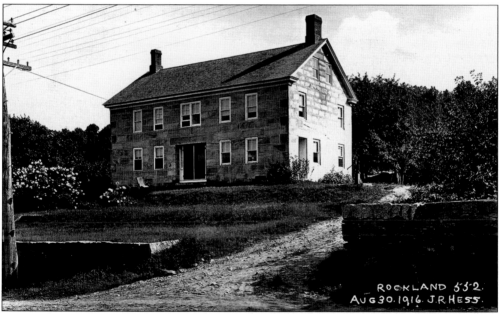

This photograph was taken of Vivian M. Potter's homestead, on August 30, 1916, just south of Battey's store. It was a stately house and a sad day when it was taken down. It appears she is staying in her home as long as possible. The following verses are from "I Carried Their Mail" by Helen O. Larson: "Many years ago in Rockland, I carried the mail each night / I carried Mrs. Potters', the lady with hair so white. I carried the mail for Sgt. Potter also, he was old and feeble back then / I wish I could bring back those days, and carry their mail again."

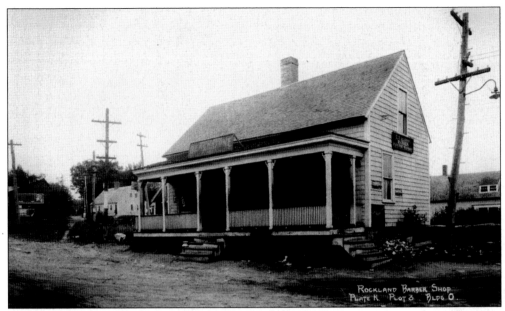

This is the T. F. Lyons Barber Shop according to the sign on the side of the building, and it also reads "electric massages." The sign over the porch reads "Wait & Bond, Blackstone, 10 cent cigars, F. J. Arnold." There are three small signs on the side of the building. They individually read, "We sell Kelley's ice cream," "Franklin cigars," and "Kibbe's candies." It appears there was quite a variety.

Rockland was a very busy village with three mills. It was able to support two barbershops. This one was owned by George E. Hill and located on the Rockland to Richmond Road. The people in the villages were not rich, but they were hardworking, honest people. The men would use the barber when they could afford it, however the children's hair was usually cut at home. The sign over the porch simply reads, "barber." John R. Hess took this photograph on August 30, 1916.

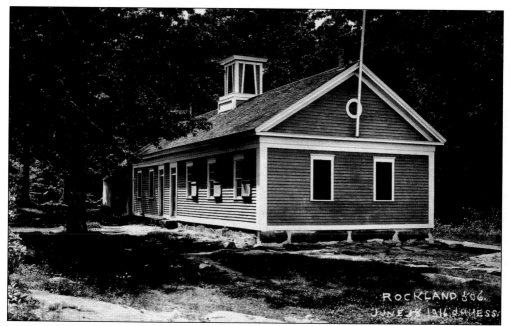

Scituate School District No. 19 schoolhouse was located on the Rockland to Ponaganset Road just outside of Rockland. Both Rockland and Ponaganset students used this school. School would have been out for summer vacation when this photograph was taken on Sunday, June 18, 1916.

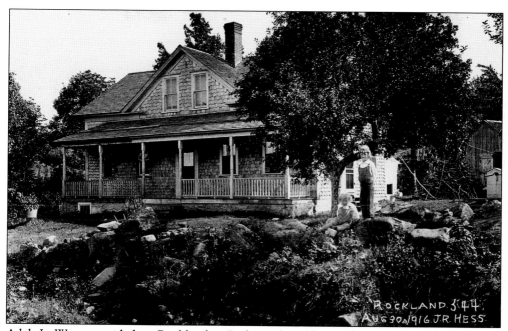

Adah L. Warner resided on Rockland to Richmond Road, just west of George P. King Road. Her two daughters on the wall were probably curious about the "man from the city" taking their picture on this beautiful Wednesday, August 30, 1916. The older one would be off to school next week.

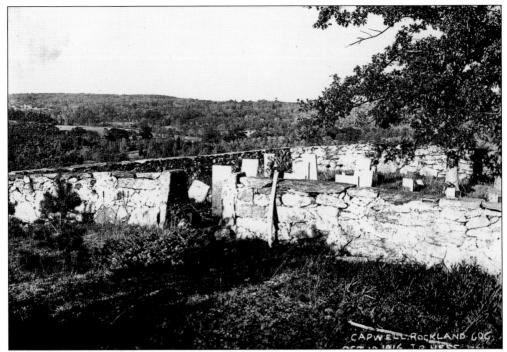

This photograph, taken on a sunny Tuesday in October 1916, captures one of the cemeteries spared from relocation. This cemetery is high on a hill on the Rockland to Richmond Road. The water of the reservoir is presently in the valley to the north. This cemetery was untouched and remains there today because it was out of the flood zone. Fortunately the residents were to remain resting in peace.

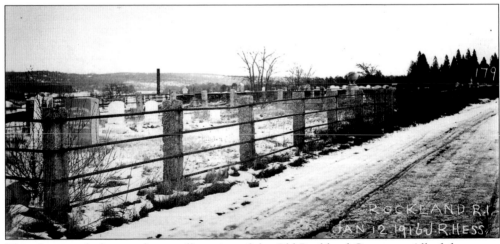

This photograph shows only a small portion of the Old Rockland Cemetery. All of the graves had to be relocated to the New Rockland Cemetery. This area was totally flooded when the reservoir was filled. John R. Hess was still out taking photographs on this cold Wednesday, January 12, 1916.

Two

THE LOST VILLAGE
OF ASHLAND

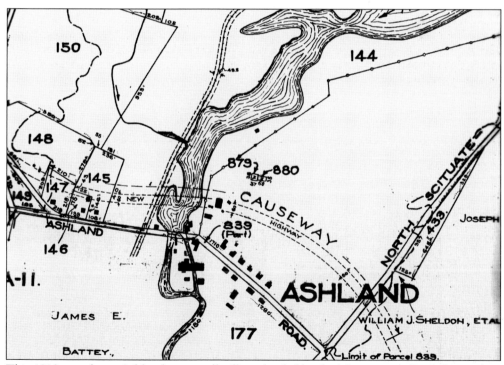

This 1916 map shows Ashland as a small village divided by the Moswansicut River. Located on the Ponaganset to Ashland Road, it was just west of the North Scituate to Kent Road. It also shows the relocation of the new Plainfield Pike that would traverse over the proposed half-mile causeway, less than 400 feet north of their village, named the Ashland Causeway and completed in 1925.

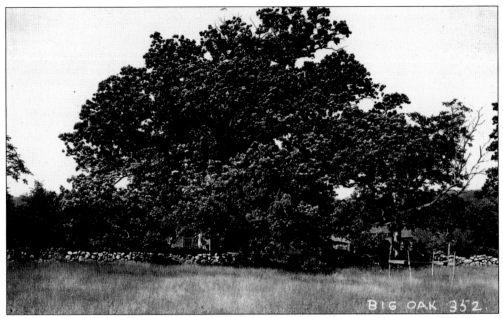

Ashland was known for a white oak of great size and age fondly referred to as Big Oak. It was located a little west of the village of Ashland on the Ashland to Ponaganset Road. When this photograph was taken on June 18, 1916, the tree had its full foliage. The house behind it is almost totally hidden. The photograph below was taken from about the same spot on December 4, 1916. The leaves have fallen as winter sets in. Alma M. Paine and her family enjoyed the shade of this huge oak all day because her house was on the north side of the road.

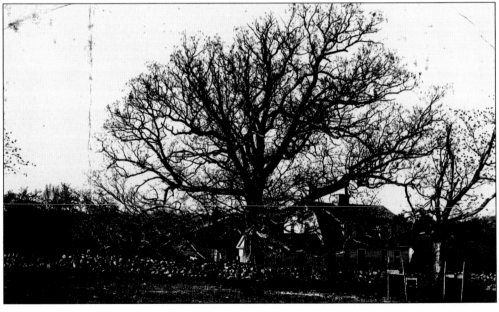

This photograph, taken on December 4, 1916, shows how huge Big Oak really was. Taking measurements at six feet high, the circumference was 13 feet and across 50 inches. At the base, it was 95 inches side to side with a circumference over 25 feet. It was said to be the largest oak in Rhode Island having a spread of branches of about 115 feet. In 1916, Big Oak was estimated to be over 200 years old. The following verse is from "Dear Old House" by Helen O. Larson: "When I was a child many years ago / There was a dear old house where I used to go. This dear old house was beside an old oak tree / And it still lives today in my memory."

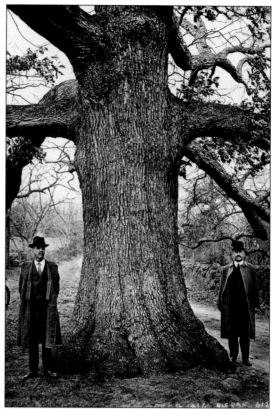

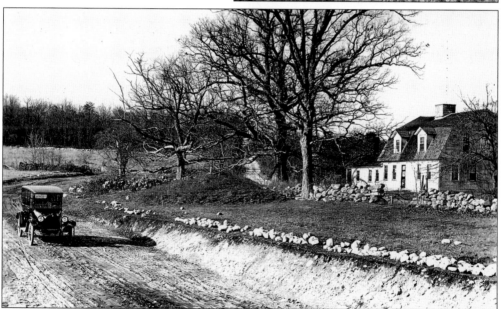

When it came time to widen the Ponaganset to Ashland Road, it was decided not to cut down Big Oak but to divert the road around it as this November 24, 1918, photograph records. Big Oak survived until the 1980s, when deterioration, vandalism, and Father Time finally took their toll.

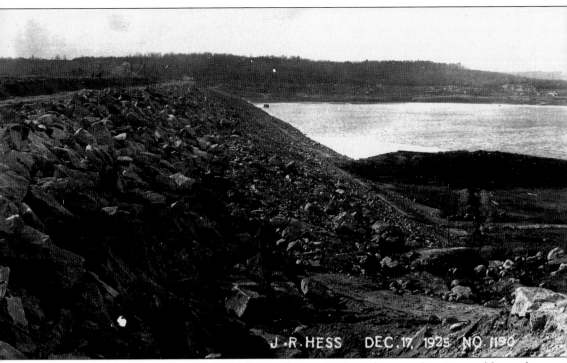

The city began filling the reservoir on November 10, 1925, and, as can be witnessed here, the village of Ashland is no longer. On December 17, 1925, the rising water has already buried the foundations. The reservoir was not completely filled until almost a year later, on September 30, 1926. The water treatment plant was also put into operation the same day. The half-mile causeway construction began on June 26, 1923, by the Thomas R. McGovern Company of Southbridge, Massachusetts. Paving began in 1928 and was completed on February 10, 1928. The causeway was accepted by the state on July 5, 1928.

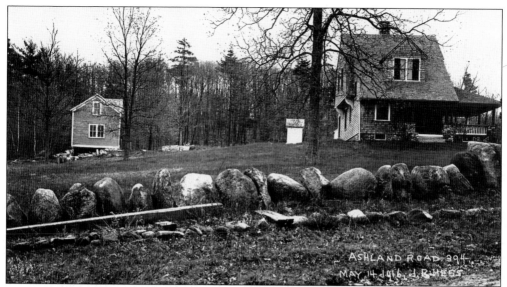

Joseph T. Sheldon and his family lived at the junction of Ashland Road and North Scituate to Kent Road on this modest one-plus-acre lot. However, they also owned 26 acres adjacent. His dad also owned three acres next door to that. It appears his dad, William J. Sheldon, retained three acres and gave or sold the balance of his farm to his son. William's house is old and Joseph's is new as this May 14, 1916, photograph shows.

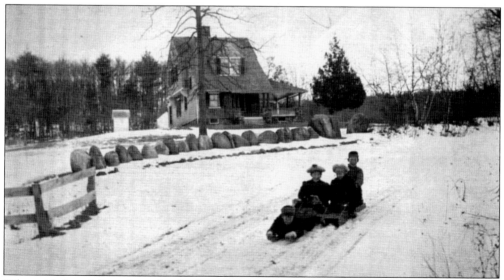

Who said they did not have fun back in the good old days? The Sheldons take time out from their busy work schedule to do just that. They had fun sliding down the hill and did not have to worry about traffic or even a single car passing by. (Courtesy of Shirley Arnold.)

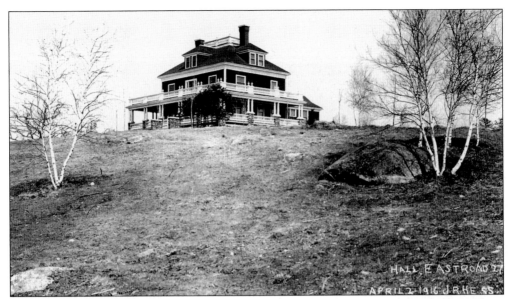

Charles C. Hall owned this impressive home on top of a hill overlooking North Scituate to Kent Road with a half-acre pond in his backyard. The railing around the top of the roof is called a widows walk. When fishermen went to sea, the wife would go to the roof via a special staircase and would watch and pray for the safe return of her husband and never to be a widow. Looking to the right of his house and in front of the pond, Hall could look upon this lovely barn and silo. With 51 acres, available water, and a barn like this, it is most certain he had a herd of cows.

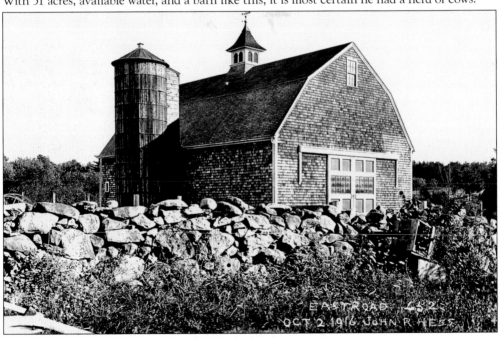

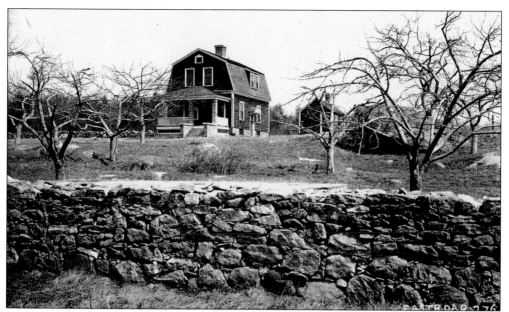

Both of these photographs were taken on April 2, 1916, from the North Scituate to Kent Road near William T. Henry Road looking easterly. Hall owned both of them as they were on his 51-acre farm. There appears to be a third house behind the one above. At the time, it was customary to build housing for one's children as they married and started their own families. Most likely, Hall would have deeded each of them a parcel of land in the future. Unfortunately the future held different plans. The farm was located in the watershed area between Saundersville and Ashland.

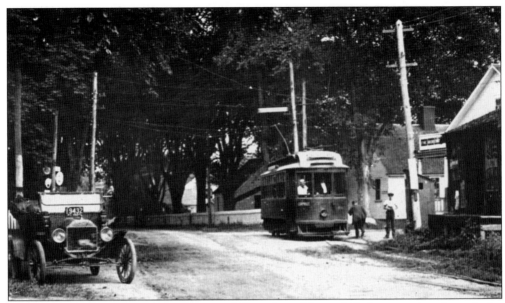

This photograph shows the Providence and Danielson (Electric) Railway passing through the village. The electric lines overhead can be seen with the arm that traveled the line and gave the trolley its power. The track followed the road system and went village to village to North Scituate where one could transfer to the railroad train to continue to Providence or Danielson. Seen below, one of the cars derailed and landed in the river. The location and date of this accident are unknown. (Courtesy of Shirley Arnold.)

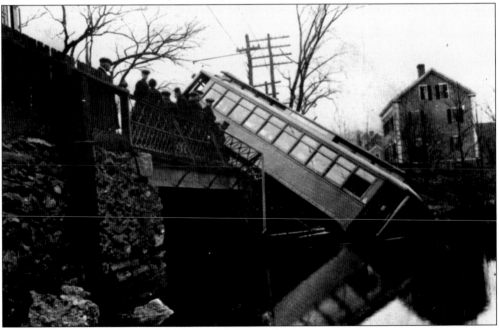

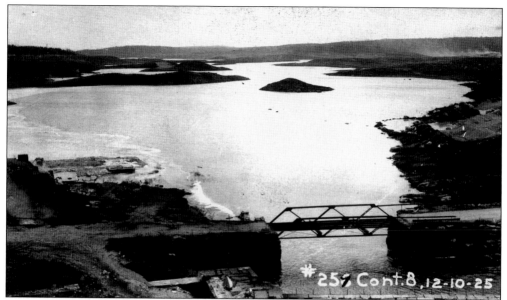

This is a view of the reservoir looking south over the Moswansicut River valley. It was taken from on top of the west end of the Ashland Causeway. In the foreground is the bridge that carried the Ashland to Ponaganset Road over the Moswansicut River into the village. The village would be located to the left. The path of the river has almost disappeared as it is being consumed by the mounting water.

This photograph is looking north toward the Ashland Causeway. Two of the three openings in the conduit under the causeway are still above the rising waters. To the left (or west) of the conduit is where the above picture was taken. In this picture to the left, and just below the causeway in the water, the very top of the same bridge can be seen. It is almost totally submerged. The village has now vanished forever.

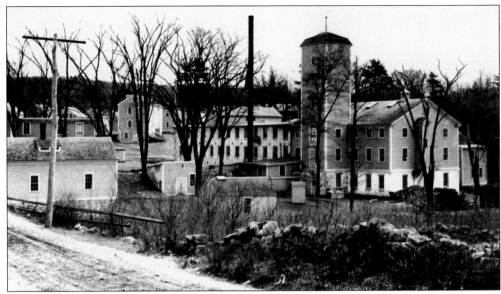

When traveling down Ashland Road, one would cross the bridge over the Moswansicut River, bare to the right, and enter the village. The Ashland mill is on the right with the church belfry to the left of the mill tower. The following verses are from "I Used to Walk the Dusty Roads" by Helen O. Larson: "I used to walk the dusty roads, many miles each day / I had to go to the store for groceries, and the store was far away. At age 14 I had to go to work in the mill, the family needed my pay / And once again I wonder, why I didn't run away." (Courtesy of Shirley Arnold.)

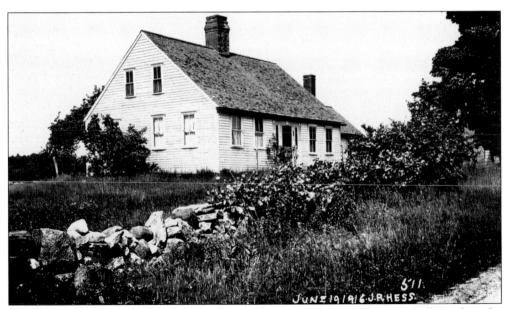

Ralph F. J. Drabble lived just on the outskirts of the village east of Chopmist Hill Road on the north side of Ashland to Ponaganset Road. He maintained a 36-acre farm, and it appears that on this Monday in June, he has not been willing to leave his land yet.

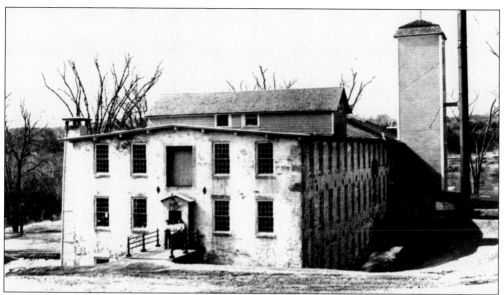

The Ashland Company was incorporated in 1847 and manufactured cotton goods. In 1858, the company built the Ashland Church for its workers and offered it to all denominations. The owners settled with the City of Providence for $195,000 on April 19, 1916. At the time, they employed 60 people that ran 5,000 spindles. The floor space allotted for manufacturing equaled 20,000 square feet. The photograph below gives a view of the back of the three-story mill. Note the two outhouses, one for her and one for him. Was someone raising chickens in the foreground? (Courtesy of Shirley Arnold.)

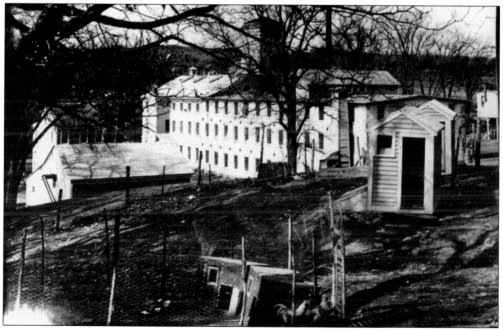

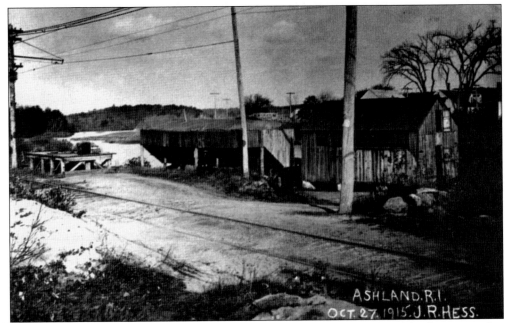

Evidently when the Providence and Danielson Railway passed through Ashland, it stopped at this loading platform. When the tracks needed to be removed and relocated because of the reservoir being built, the company decided not to replace its tracks and shut down for all time.

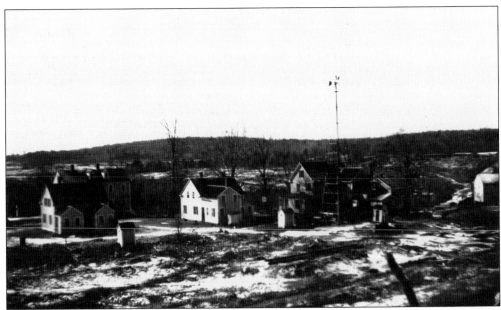

This photograph was taken from on top of the causeway looking south at the village. The villagers have been living there almost 10 years since they were given notice of condemnation. However, their days are limited and their time is running out, and the remaining residents must move away. The following verse is from "My Hometown" by Helen O. Larson: "The buildings were demolished, the city bought them one day / To build the Scituate Reservoir, they took our beloved village away." (Courtesy of Shirley Arnold.)

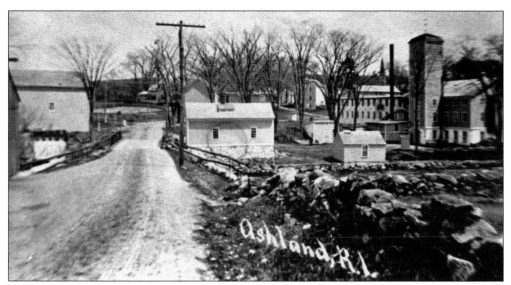

This photograph was taken standing in Ashland Road looking east and places the Ashland Mill on the south side of the road. The steeple of the Ashland Union Church can be seen to the left of the mill tower. The majority of the village would be in that general vicinity. (Courtesy of Shirley Arnold.)

This is a copy of the Ashland Mill census. It is interesting to see 42 men cost the company $800 a month while 35 women only cost $400. Working 10 hours a day, 6 days a week, workers received approximately $19 for men and $11.50 for women per month.

		1860	1870
Mill		Ashland Mill	Ashland Company
Owner		Ashland Company	N/A
Type		Cotton Works	Cotton Sheeting
Capital		$60,000	$7,200
Male		42/$800 per month	43/$21,000
Female		35/$400 per month	31/$21,000
Children		N/A	N/A
Quantities		800,000 yds	300,000
Kinds		3/4 sheeting	cotton supplies
Value		$45,000	$75,000
Item		Cotton 160,000 lbs	Light Cotton Sheeting
Item Value		$20,000	$104,000 /1,600,000 yds
Item		Coal 30 tons	
Item Value		$300	
Item		Starch 4 tons	
Item Value		$300	
Item		Oil 700 gallons	
Item Value		$1,000	
Item		Manufacturing Gas	
Item Value		$100	
Miscellaneous		1,000	
Power			water power (90 hp)
Machinery			frame spindles 2,580
			mule spindles 2,580
			looms 100

This is the main street traveling through Ashland in the summertime. It seems all is quiet and peaceful; however, behind these houses all kinds of construction was going on. To the right of the photograph one can see the Ashland Causeway being built. To the left is the 90-foot cableway dragline excavator tower. (Courtesy of Shirley Arnold.)

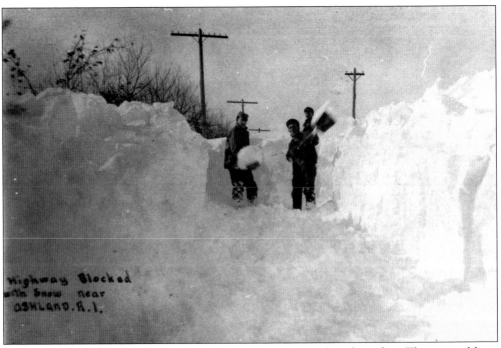

Back in the day, if one wanted to go somewhere, one had to shovel out first. This seems like it was a very tough winter. The following verse is from "Upon the Christmas Tree" by Helen O. Larson: "Stringing cranberries and pop corn, wrapping Christmas gifts too / We were tired but happy children, when the day was through." (Courtesy of Shirley Arnold.)

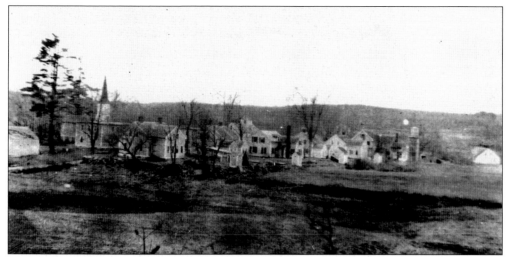

This is the sleepy little village of Ashland. The photograph was taken from the Providence and Danielson Railway tracks just outside of the village. The new Plainfield Pike Causeway is located approximately where the white barn is to the very right of the photograph. This area is totally submerged today. (Courtesy of Shirley Arnold.)

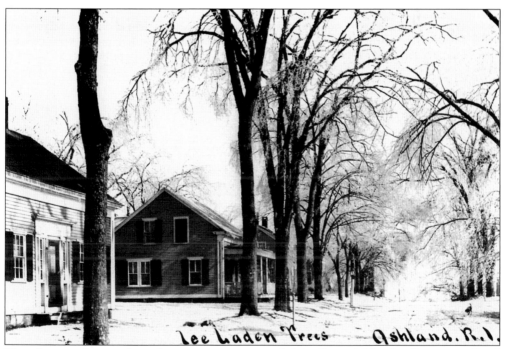

This photograph was taken after an ice storm covered the village. Ashland to Ponaganset Road was the main street in Ashland. It appears so quiet and peaceful, but in a few years it was doomed to be destroyed and covered with water and ice instead of snow and ice. The following verse is from "Upon the Christmas Tree" by Helen O. Larson: "It was at the homestead, in a corner of the room / Stood the Christmas tree, and it ended all too soon." (Courtesy of Shirley Arnold.)

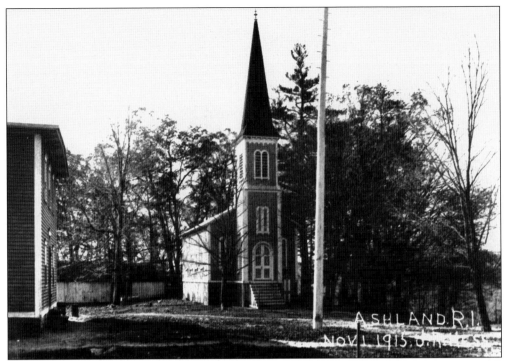

The Ashland Union Church, built in the 1850s by the Ashland Mill Company, was open to all denominations. It was located on Ashland Road at the edge of the village. If the church were still there today, the water line would be at 37 feet or right where the black roof meets the white tower. This was how the church looked on November 1, 1915. (Courtesy of Shirley Arnold.)

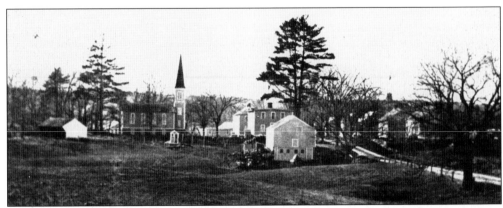

Is it easy to picture this entire valley filled with water? It certainly was not for the residents. The following verses are from "The Old White Church" by Helen O. Larson: "The bell would ring Sunday morning, it would toll so loud and clear / We knew we must attend, the church we loved so dear. Yes, that dear old white church by the roadside / they tore it down, now the foundation the water hides." Ashland Road is to the right leading into one of the prettiest New England villages. (Courtesy of Shirley Arnold.)

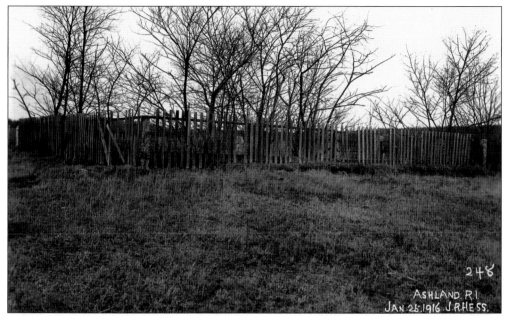

This burial place, located on the Ashland Road in Ashland, was owned by the Ashland Company. It seems to be out in the middle of nowhere and has been forgotten for quite some time. The trees have taken over the area for lack of attention. The new attention it will receive after this January 25, 1916, day is to be moved to the new Rockland Cemetery outside of this area, which is doomed to be flooded.

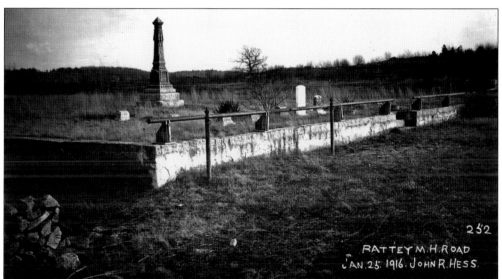

Eloi and Huldah Lacoste owned this property on Battey Meeting House Road near Ashland to Ponaganset Road, where this burial place was located before it needed to be removed. The very impressive headstone or monument belonged to M. P. Drake. Notice the two poles this side of the wall. There are rings toward the top to tie a horse to, as one visited with loved ones.

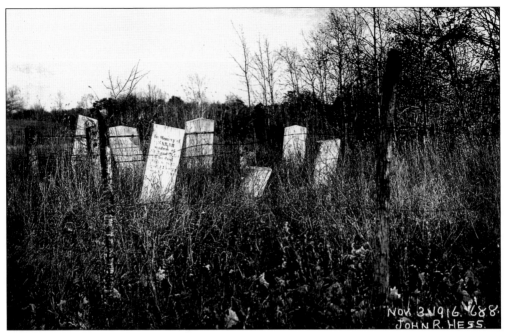

John R. Hess was finishing the week when he took this photograph on Friday, November 3, 1916. The cemetery was on the property of Sarah D. Wells. It was located on the south side of the Ashland to Ponaganset Road near Ashland. The headstones appear to be an old family plot of the 1800s.

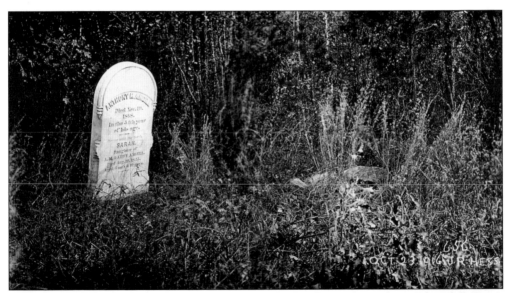

This photograph, taken on October 2, 1916, is of a headstone located on Edward F. Page's property. However, the stone reads "Anthony M. Angell, Died Nov. 10, 1868, in the 54th year of his age." Could this be a descendent of the Angell family that owned the famous Angell Tavern in South Scituate? Page's property was south of Plainfield Pike opposite Ashland Road.

Three

THE LOST VILLAGE
OF SOUTH SCITUATE

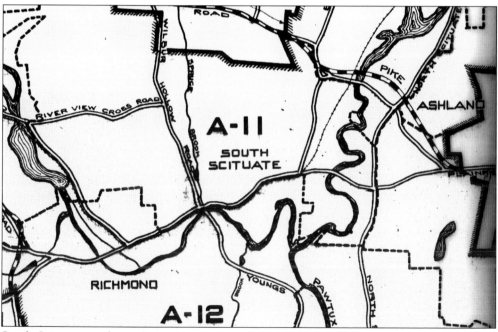

South Scituate was located along both sides of the old Plainfield Pike, at the junction of the Ponaganset and Moswansicut Rivers as they joined the Pawtuxet River. This map locates Ashland and Richmond in relationship to South Scituate, home of the old Angell Tavern built in 1711. In 1730, the first Scituate town meeting, moderated by Stephen Hopkins, took place in the hall above the tavern. The town meetings continued to assemble there until a Baptist church was built in the center of town. Hopkins later became governor of Rhode Island and was a signer of the Declaration of Independence.

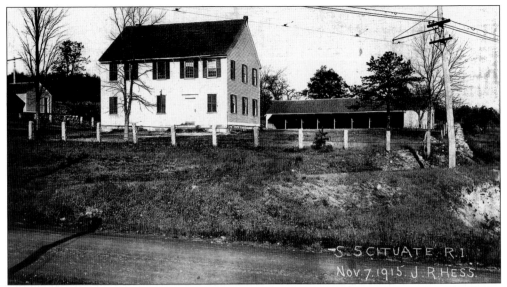

This Six-Principle Baptist Society Meeting House replaced the one built in 1726 after being granted a parcel of land near the center of the village. Samuel Fisk was ordained the first pastor. On the property was a burial parcel with between 40 to 60 burials reported that needed to be relocated. The society was located east of the junction of Battey Meeting House Road on Plainfield Pike. For 200 years, they practiced the six principles of Christ's doctrine.

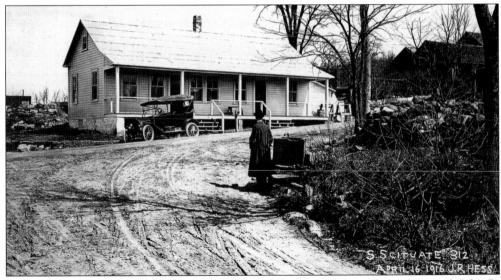

Alfred H. Williams lived in this house with Plainfield Pike at his front door, along with John R. Hess's automobile. The North Scituate to Kent Road passed to the left of his house in this photograph then continued down the hill. The parcel of land Williams owned extended between the two roads and all the way to the Ponaganset to Ashland Road.

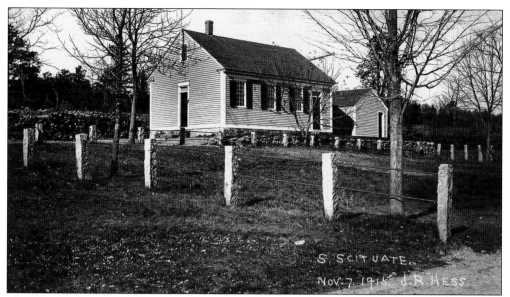

This was the schoolhouse for Scituate School District No. 13 serving South Scituate. It is showing the front and east side of the building from east of the junction of Battey Meeting House Road on Plainfield Pike. It was built on land adjoining the Six-Principle Baptist Society Meeting House.

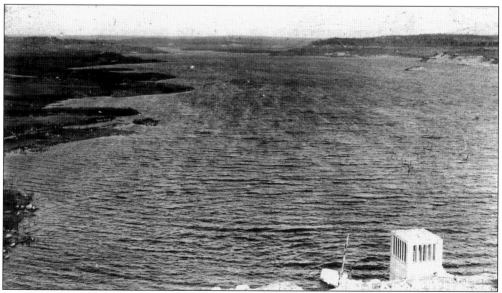

This photograph, taken on November 11, 1925, and from on top of the dam looking north, illustrates how the reservoir was filling and covering the remains of the villages. South Scituate would have been just south of the point of land in the middle upper area of the picture. Kent would be to the lower right.

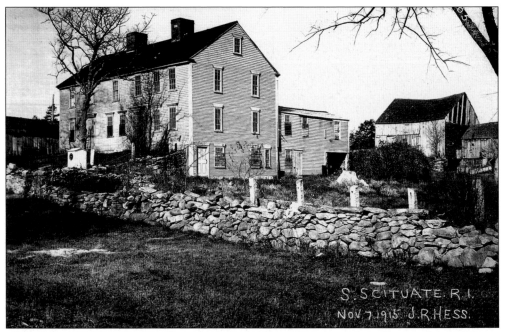

This photograph was taken on November 7, 1915, of James E. Battey's farmhouse and outbuildings. His farm was located east of Battey Meeting House Road and north of Plainfield Pike. This is a view looking northwesterly. Even though this is a double farmhouse, Battey must have had a large family to require such large living quarters.

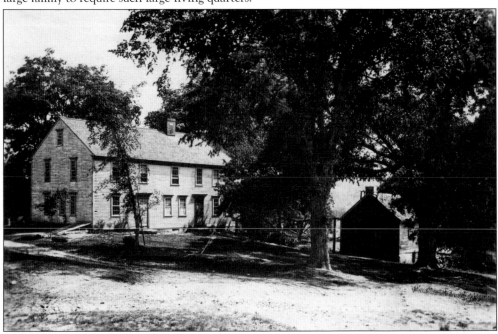

Battey and his family lived on this 90-acre farm. His frontage was Battey Meeting House Road to the west. The east boundary was the Moswansicut River. The farm covered all the land between Plainfield Pike on the south and Ashland Road to the north. Was the front road named after his ancestors?

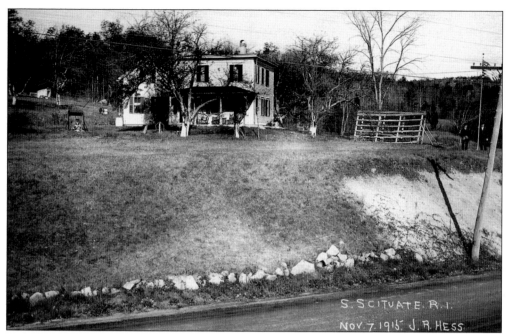

Probably one of the two men standing beside the telephone pole on the right side of this photograph is Frances J. Esleeck, whose farmhouse is shown. He could have been saying to his friend on November 7, 1915, "What the city says they are going to do will never happen."

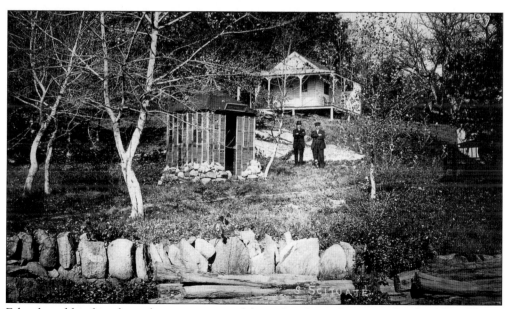

Esleeck and his friend may have just returned from church on this sunny Sunday, November 7, 1915. Both men seem real defensive in front of the small summer living quarters Esleeck had built for his family. It was located north of Plainfield Pike and east of Wilbur Hollow.

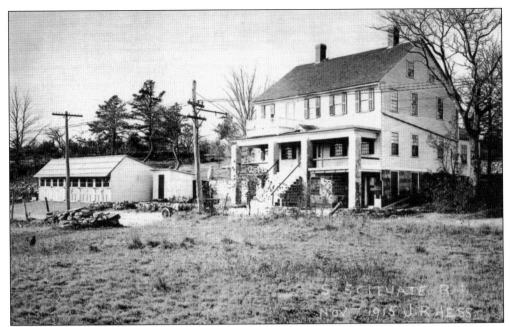

Edwin F. Shaffer lived in this house on Plainfield Pike at the junction of Battey Meeting House Road. The South Scituate Post Office located here needed to be moved to the Blackstone General Store in Richmond when the city took the house over for its engineering headquarters. Chief engineer Frank E. Winsor was in charge of the work since the beginning in 1915; however, he moved on to a position in Massachusetts and William W. Peabody took over. This Sunday, November 7, 1915, Shaffer had no idea his home would be used for the headquarters of the city engineers. Shaffer ran this automotive garage and was still working on cars that Sunday.

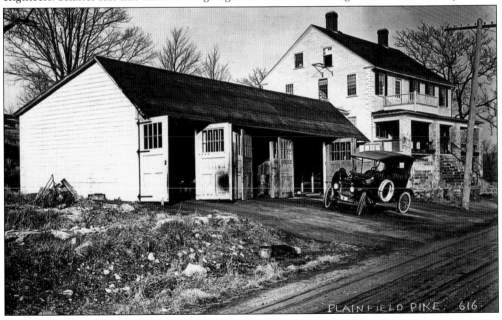

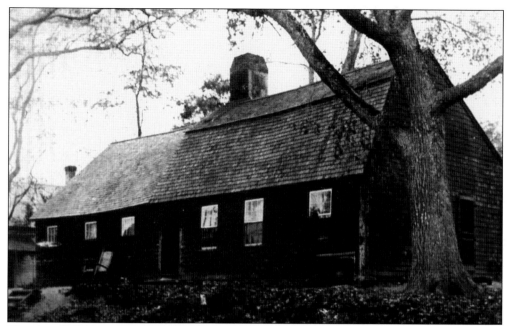

The Angell Tavern in South Scituate was the place determined for the first town meeting. Stephen Hopkins was elected the first moderator with Joseph Brown as clerk. Hopkins later became governor of Rhode Island and then a signer of the Declaration of Independence. Meetings continued here until a church was built about a mile away. (Courtesy of Shirley Arnold.)

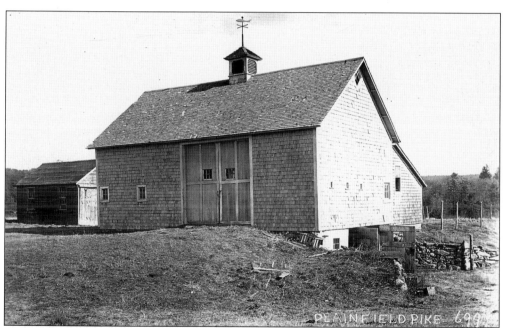

Fred W. Segee and his family lived just south of Plainfield Pike near the Shaffer House. This moderate-sized barn with the standard access beneath was located about 200 feet off the pike on his 36-acre farm including a two-acre pond. The house was to the left of this picture.

These two photographs record that work is moving along quickly. They were taken on May 3, 1917, on the property of Elizabeth J. Wilbur. All of the area to be flooded needed to have all the trees removed. To prevent rotting and polluting the water, the stumps were pulled out by teams of horses and carried away in wagons. The contract was awarded to the firm of J. Livingston and Company of New York. The wood has been cut and stacked, waiting to be sold and trucked away. This process took a number of years to complete. This whole valley, as well as all the historic stone walls, is under water today.

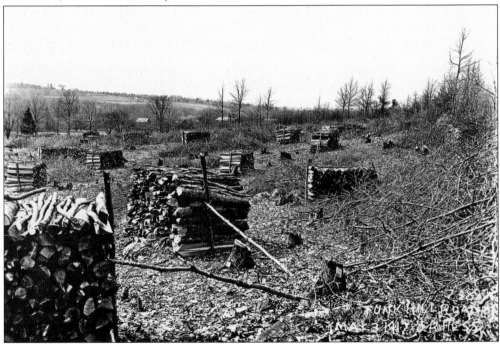

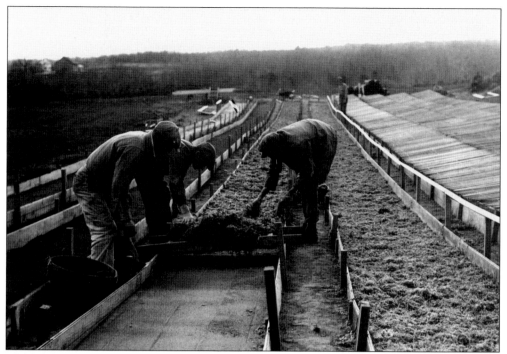

The land acquired for the reservoir contained many acres of pasture and farmland in addition to wooded areas. The growth was cleared from the margins of the reservoir for a depth of 138 feet. A program of reforestation was undertaken in 1926 to guard against erosion. These workers are spreading moss over the seedling beds at the reforestation nursery. The seedlings remained here for two years. Planting crews were given two weeks or more of instruction of proper planting methods.

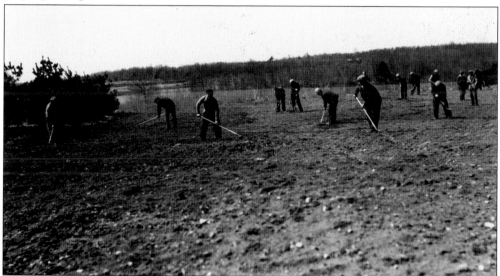

At the beginning of the reforestation program, various New England and Canadian nurseries supplied the planting stock requiring numerous handling operations. In 1934, the city established its own nursery. This crew is working an area included in 600 acres of open space and 180 acres that had previously been burned and cleared. It is being developed for transplant beds.

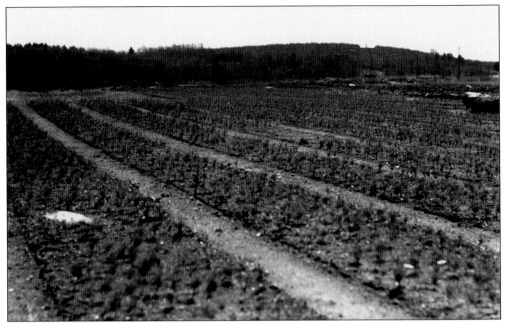

This is a field containing 32,000 two-year-old red pine transplants at the Scituate Reservoir Nursery. The transplants remained here for not less than one year before being removed for planting. Workers at the nursery were instructed in nursery procedures as well as the correct method of packing trees for delivery to the planting areas.

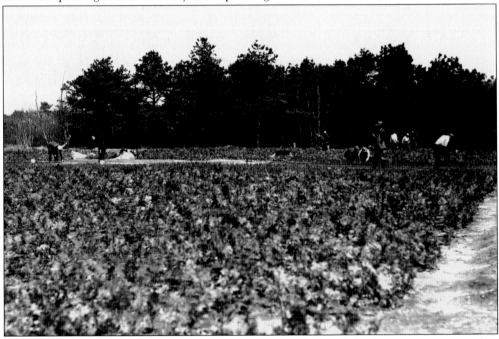

Shown here are 25,000 five-year-old white cedar transplants. Transplants were produced at the nursery at a much lower cost than the price quoted by a commercial grower. Due to the location of the planting areas and planting in favorable conditions, the mortality rate was reduced radically.

Approximately five million transplants were produced in the nursery between 1935 and 1942, when the reforestation program was temporarily discontinued because of World War II and the shortage of manpower. The program was not resumed again until 1946, when the Turnquist Lumber Company of Foster performed certain limited pruning, thinning, and harvest cutting operations. The number of plantings on the watershed property from the beginning of the reforestation program in 1926 totaled approximately 7,099,022 transplants.

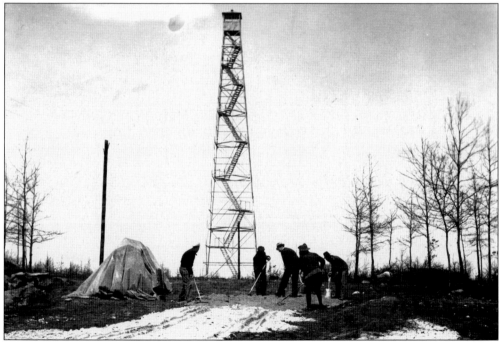

A network of fire lanes provides protection against fire losses. For further protection, this fire tower was erected in 1935 by the Atlantic Pump and Supply Company of Providence. The tower is manned during the forest-fire season and operated in conjunction with other state towers.

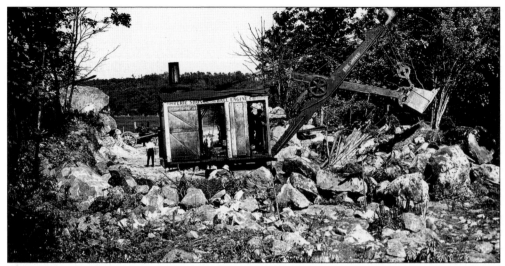

There were 36 miles of roads that needed to be abandoned as they are under water today; therefore a number of roads, equaling 26, miles needed to be constructed. While one company had a contract to excavate and build the dam another company was contracted to build relocated roads. The sign above the door states that the shovel is a type B made by the Erie Shovel and Ball Engine Company from Erie, Pennsylvania. It must have been very slow but steady progress considering horse-drawn wagons were used to dispose of the rock and soil. The material was hauled in two-yard dump wagons. Both photographs were taken on July 1, 1920.

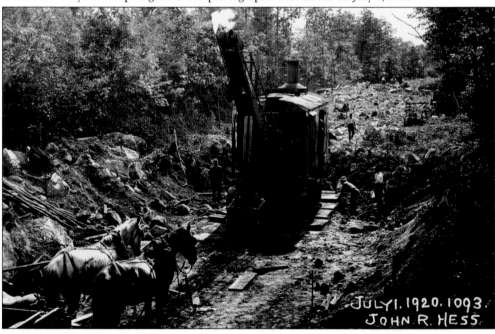

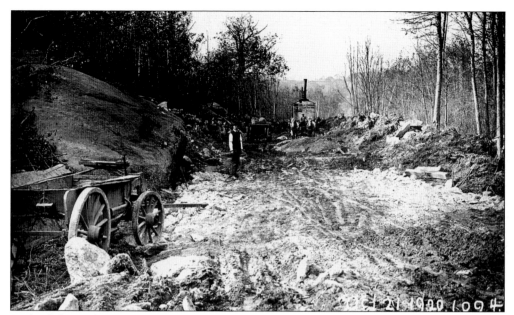

Both of these photographs, taken on October 21, 1920, illustrate the progress being made. As the steam shovel (above) is hard at work, the two horses and the driver of the wagon wait to be loaded. Just above the person in the roadbed, another team patiently waiting its turn can be seen. Field offices of the Reservoir Division were maintained at the Shaffer House in South Scituate until October 24, 1924, when the initial flooding began. Storage of water in the reservoir forced the evacuation to the village of North Scituate along with the Dam and Aqueduct Division's field office located near the village of Kent.

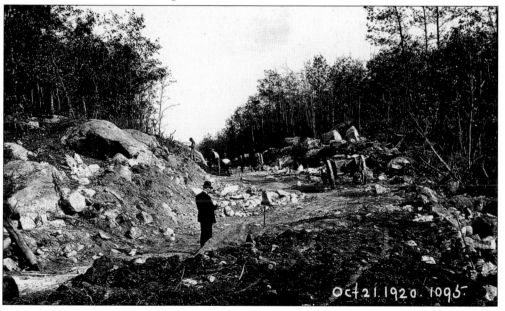

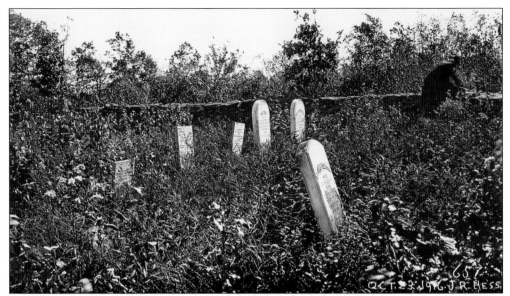

This burial place was located north of Plainfield Pike, northwest of the Shaffer House on William Pages's farm. The smallest headstone in the back row to the left reads, "in memory of, three children, of Doet Owen Battey, and Ruth his wife." There are no names or date listed. Did Ruth loose the three babies giving birth? All the residents of this sacred place needed to be moved to another location so as not to be under water when the reservoir filled.

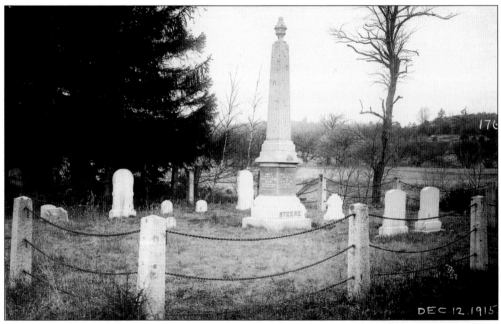

Andrew Steere's ancestors' burial place was on the family farm located opposite Shaffer House on Plainfield Pike. The huge monument records that Asahel D. Steere died on October 22, 1881, in the 62nd year of his life. His daughter Abbie A. was born on November 22, 1848, and died on January 7, 1894.

Four

THE LOST VILLAGE
OF RICHMOND

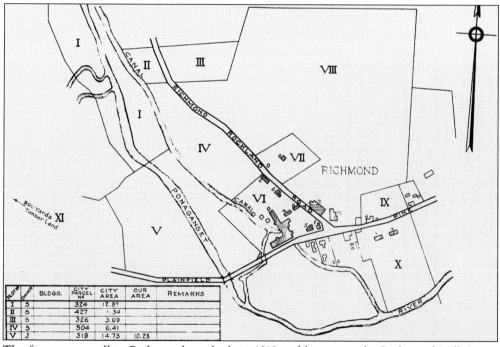

The first cotton mill in Richmond was built in 1813 and known as the Richmond Mill. It was acquired by Robert E. Joslin in 1868 but was destroyed by fire in 1874. Robert's son William E. rebuilt the mill in 1875–1876. By 1899, it was under the umbrella of the Joslin Manufacturing Company. The company owned 11 mills in Scituate from 1875 until 1906, when the Joslin family transferred ownership to another of their holding companies, the Scituate Light and Power Company. It was all sold to the City of Providence in 1925 for $1,725,000.

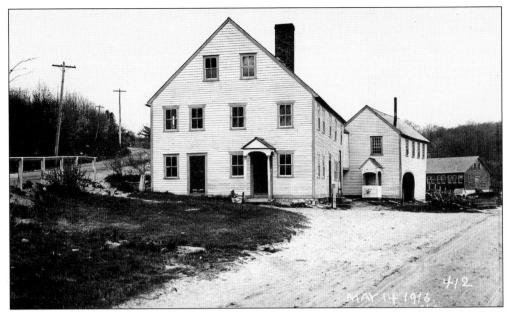

Daniel H. Remington owned this large house that appears to be connected to the one beside it. It was located on the corner of Fields Hill Road and Plainfield Pike. It was known in town as the Patterson homestead.

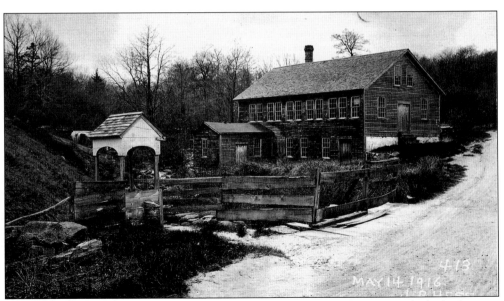

Just down from Remington's property on Fields Hill Road and across a little bridge was E. C. Wightman's shop. He only had an acre of land on this small brook. It appears to be a well-maintained building, maybe a gristmill.

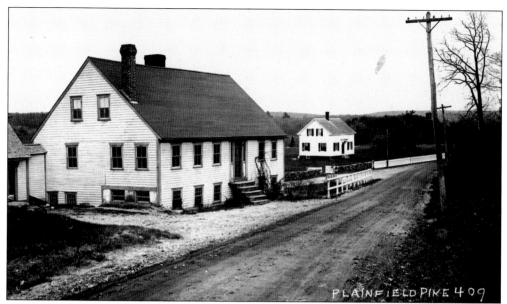

This is the view of Remington's house as one traveled down Plainfield Pike to the intersection of Fields Hill Road on the way to the village of Richmond. The way the house was built into the hill, it was almost a walk out from the second floor. As of May 16, 1916, electricity finally came down the pike; however, it appears Remington has not hooked up yet and probably will not be. He also owned the house (below) across Fields Hill Road from Wightman's shop. It was a duplex that he rented out. Unfortunately electricity did not go up side roads at this time.

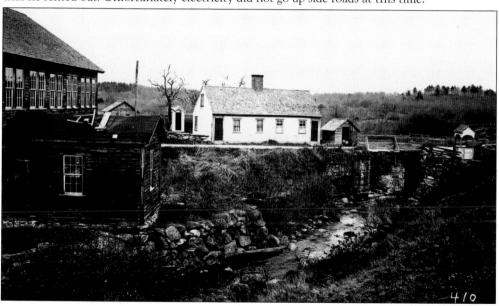

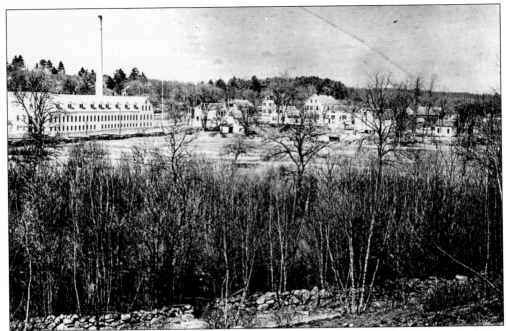

This photograph was taken from on top of a hill on the south side of the Ponaganset River. The river turned here heading east for a while before turning south again at the junction of the Moswansicut River as they both flowed into the Pawtuxet River heading to Kent and beyond. The following verse is from "The Old Stonewall" by Helen O. Larson: "Looking down at the valley below, as I stood by a wall on a hill / A little village snuggled there neatly, it almost caused my heart to stand still."

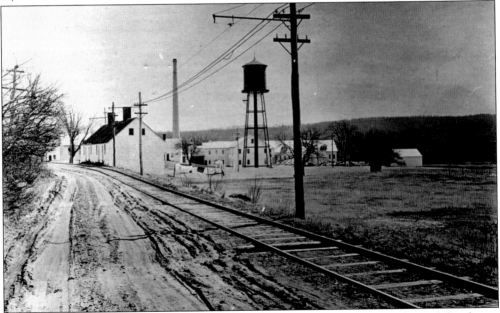

The Providence and Danielson Railway followed alongside Rockland to Richmond Road as it entered the village of Richmond and intersected with Plainfield Pike. William H. Joslin had started building water towers because of so many mill fires. He also added sprinklers at the same time.

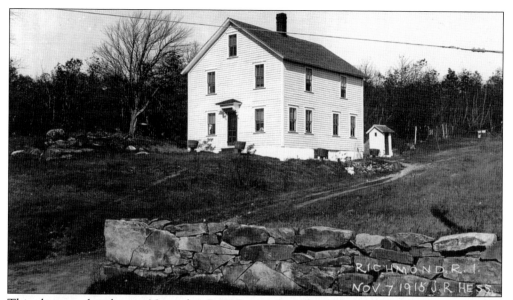

This photograph, taken on November 7, 1915, was of another Joslin property. It was occupied by the superintendent of the mill and located across from the mill on the Richmond to Rockland Road. He enjoyed the use of the two-acre farm, including the good old outhouse.

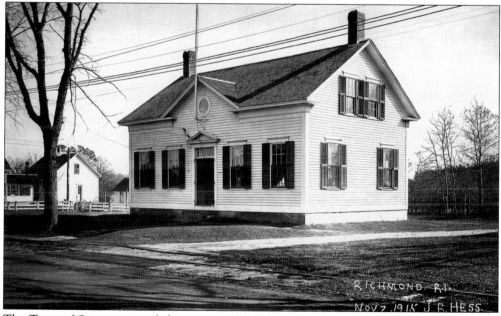

The Town of Scituate owned this municipal building situated on a half-acre lot on Plainfield Pike on the very edge of Richmond Village. Before this building was destroyed, all the village records were transferred to the town hall in the village of North Scituate, where the records are still maintained today.

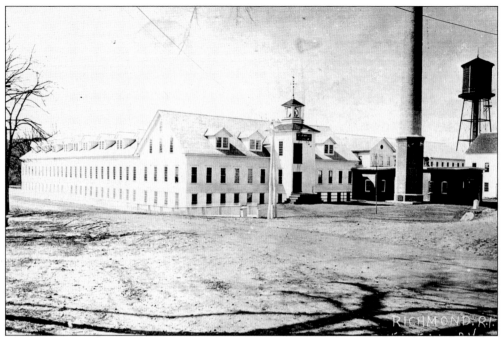

This photograph of the Richmond Mill Complex, taken on March 15, 1915, is looking southwesterly on Plainfield Pike at the junction of Richmond to Rockland Road. The Ponaganset River was the source that supplied the engine room with power. Downstream from Richmond, it met the Moswansicut River to join the headwaters of the North Branch of the Pawtuxet River. This was a time when the mill was running at maximum productivity.

This photograph was taken in about the same location and facing the same direction as the one above, only 10 years later. The Ponaganset River is no longer. It has been swallowed up by the rising waters of the reservoir. As it creeps toward the photographer and the village, it is already burying the Richmond Mill. The entire village now lies silently beneath 57 feet of water. This entire valley has been consumed.

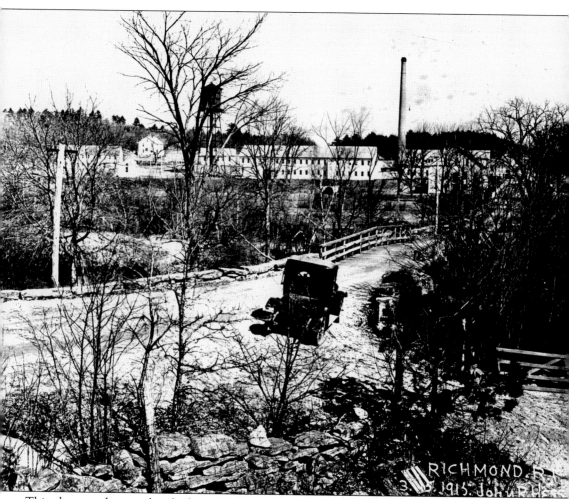

This photograph was taken looking northeasterly along Plainfield Pike. It shows the rear of the Richmond Mill Complex as one approached the village and the intersection of the Richmond to Rockland Road. The mill was built in 1813 by a company of about a dozen persons. However, before going into business they sold it to Messrs. Bullock, Richmond, and Andrews, who ran it until 1840. It then passed through many hands until January 1874, when it was destroyed by fire. William E. Joslin then bought and totally rebuilt it in the spring of 1876. It had a capacity of 60 horsepower and contained about 500 braiding machines. Joslin Manufacturing Company was a world leader in manufacturing shoelaces and corset lacings. The workers were paid about $2 a day and worked six days a week. The following verse is from "Buildings That Were Destroyed" by Helen O. Larson: "The mills were destroyed where our fathers worked each day / Oh! The pain and heartache to see them torn down and carried away." It appears John R. Hess took this photograph on a clear cold Monday, March 15, 1915.

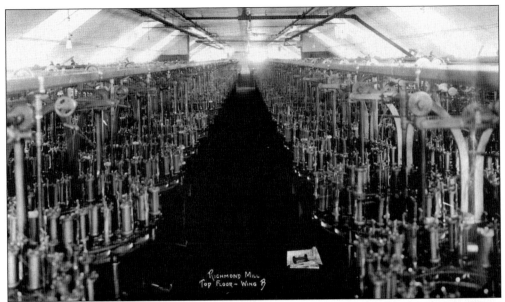

This is the top floor of wing B of the Richmond Mill waiting silently to be stripped of all its machinery. They are part of what at one time made the Joslin Manufacturing Company a world leader in the manufacture of shoelaces and corset laces.

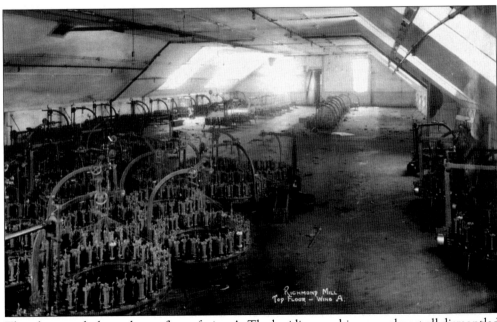

This photograph shows the top floor of wing A. The braiding machines are almost all dismantled and taken away. After operating for over 100 years, it was silenced and doomed for demolition. The foundation of the mill now lies 50 feet below the surface of the Scituate Reservoir.

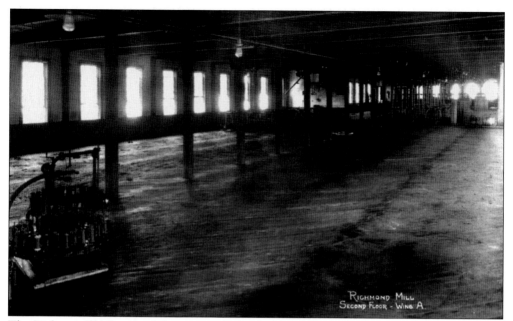

The Richmond Mill, second floor, wing A, has been totally cleaned out. However there is one last braiding machine that served its master well producing thousands of laces over time. It appears to be saying its last good-byes before it too is carted away. This had to be a very sad day for all concerned.

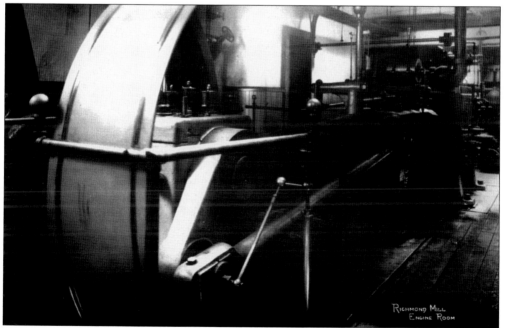

This photograph shows the engine room and powerhouse of this great mill. It was located on the first floor and produced 60 horsepower to run the 500-plus braiding machines. As it shows here, all the equipment was kept in top-notch condition.

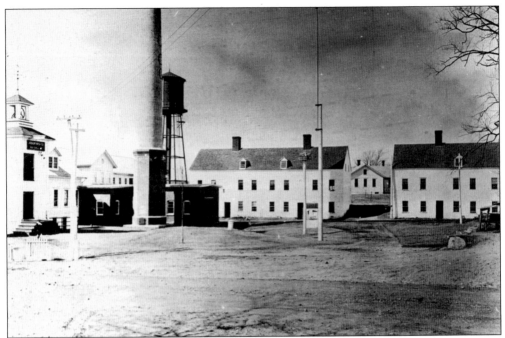

This photograph depicts two eight-tenement buildings William H. Joslin had built to rent to his workers. A tenement in one of the buildings could be rented for $2 a month. They were located on the west side of the Richmond to Rockland Road just outside of the mill complex, no excuse for being late. The smokestack of the mill can be seen to the left of the buildings, along with the water tower. These were two of the many he built.

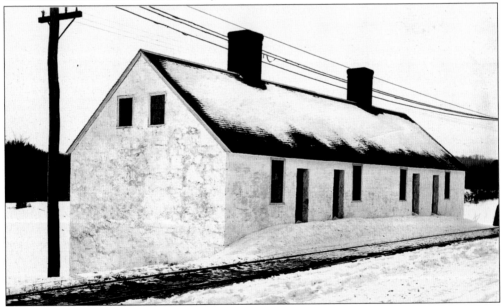

This is another of Joslin's huge tenement buildings. It appears the people have already moved away, and it is waiting to be demolished. With the mill being dismantled, there was no work and no means of making a living. Therefore the people had no choice but to move on with their lives. Trolley service was at the front door on this cold and snow-covered Tuesday, February 22, 1916.

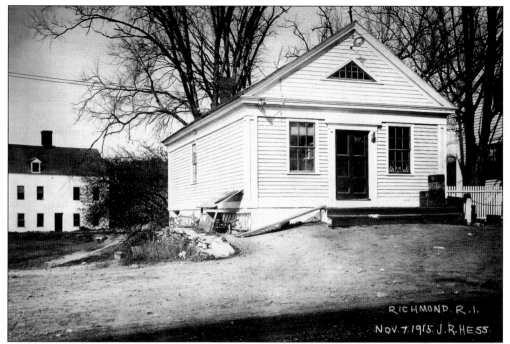

Joslin had this general store built to keep his workers supplied with all the essentials. The storekeeper kept a pad to record each family's order. At the end of the week when they were paid, they would stop at the store to pay the slip. This is why the lyrics of a song at the time rang out "I owe my soul to the company store." The map on page 63, plot number VI, shows the mill complex, tenement buildings, and the store.

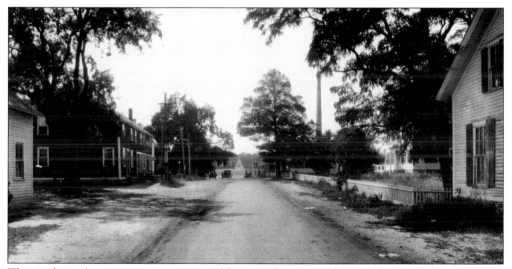

This is the welcome view someone would see as they entered the village of Richmond when traveling Plainfield Pike from North Scituate. The two gentlemen sitting on the step would most certainly have greeted them. The general store on page 75 is at the end on the right and the Richmond Mill is in the center.

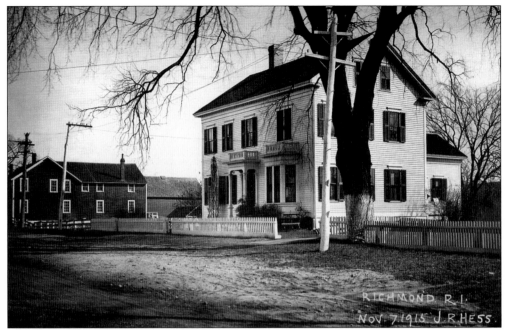

This was the beautiful summer residence of Theresa B. Joslin, the mother of William H. Joslin. It was positioned directly across from the mill complex on Plainfield Pike. This was a convenient location with the stores across the pike, the post office up the pike a short way, and the trolley at her front door. An interesting point is that when they painted the fence white they included the tree.

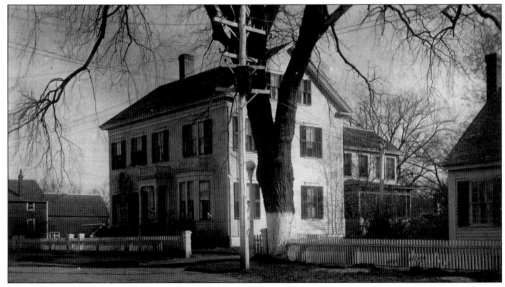

This photograph, taken on November 1, 1922, proves Theresa was not sitting around waiting for the city to take her house. Comparing the photograph at the top taken on November 7, 1915, progress in the making can be seen. She added a large addition in the rear, and there is a new taller telephone pole with four arms and a transformer. Also electric lines have continued down Plainfield Pike.

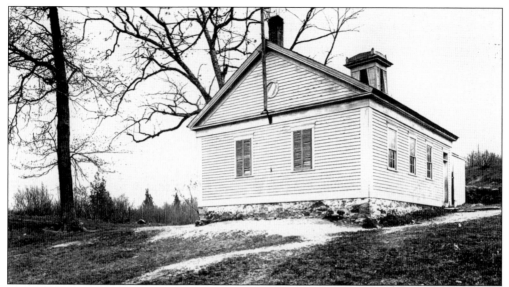

The Richmond School was located on the south side of Plainfield Pike near the junction of Fields Hill Road. It was a quiet hazy Sunday when John R. Hess snapped this photograph on May 14, 1916. The children were home hopefully enjoying their day off. In less than a month they would be on their summer break. The following verse is from "My School in Rockland" by Helen O. Larson: "The school is gone now, they tore it down one day / Then picked up the boards, and took them away."

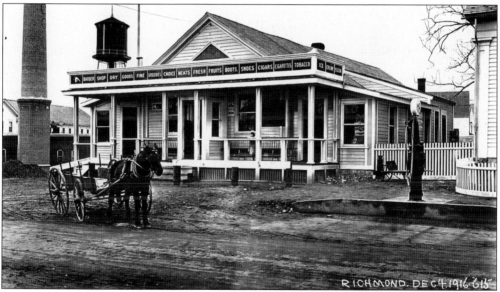

This store owned by the Joslin Manufacturing Company was located on Plainfield Pike near the Richmond to Rockland Road. They advertised a barbershop, dry goods, fine groceries, choice meats, fresh fruits, boots, shoes, cigars, cigarettes, tobacco, ice cream, and soda. The little girl on the porch is either watching the horse or hiding her head from Hess taking her picture. Note the gas pump at the side of the road, a forerunner of the common convenience store setup today.

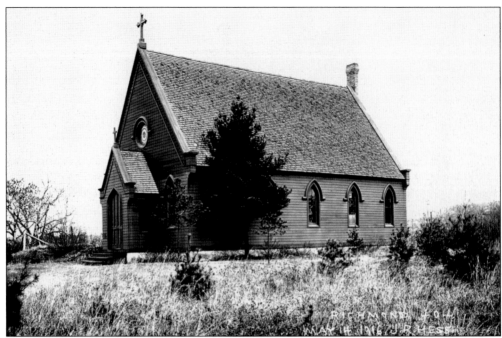

This photograph of the Rhode Island Trinity Episcopal Church was taken on May 14, 1916. It was located on Plainfield Pike near the Rockland to Richmond Road. The burial ground located on the opposite side of the church, as shown on page 84, needed to be removed and transported to the new Rockland Cemetery.

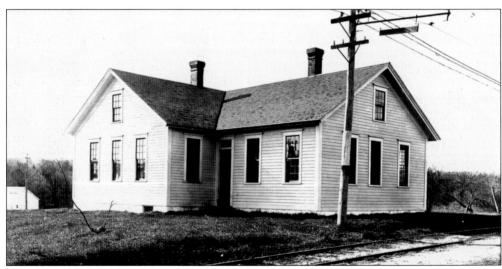

This is another Joslin-owned tenement house located on the west side of Richmond to Rockland Road being part of the mill complex property. The Providence and Danielson Railway traveled from North Scituate to Richmond following Plainfield Pike. The electric lines for the trolley can be seen overhead.

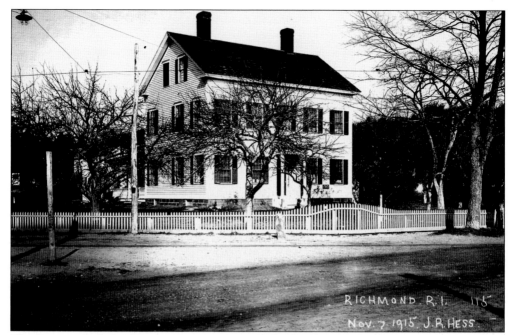

The Scituate Light and Power Company owned this building at the intersection of Plainfield Pike and Richmond to Rockland Road. This house is located across the street from the post office. Notice in the top left corner of this photograph is a great example of the old streetlights.

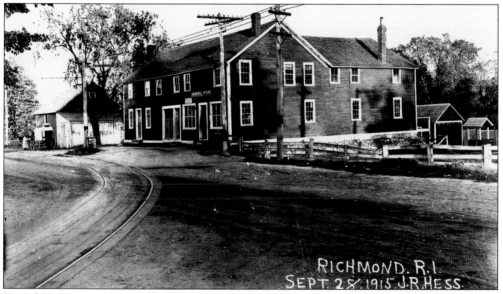

Daniel H. Remington proudly states he is the proprietor of the Blackstone General Store. On one side of the sign is advertised he has "Smith and Sons" and on the opposite side, "10 cent cigars." The sign over the window reads "South Scituate Post Office Richmond Village." The Providence to Danielson stage line, the last stagecoach line operating in Rhode Island, was doomed when the Providence and Danielson Railway opened in June 1901.

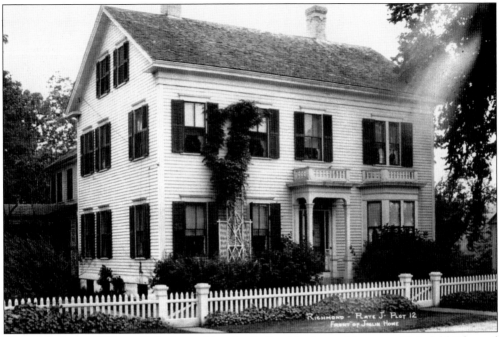

This is the home William H. Joslin and his family lived in, located between Plainfield Pike and the Ponaganset River in the village, not too distant from his mill. There was a large addition in the rear of the building along with outbuildings as shown in the photograph below. To the right of the photograph above can be seen the corner of his over-sized garage. This estate was the Joslins summer home. In winter they lived in Providence.

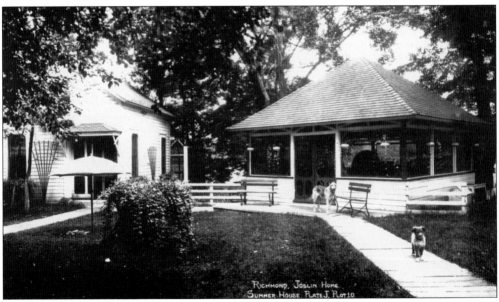

The small building to the left could have been used as a guesthouse or even in-law quarters. The family surely spent many delightful evenings in the screened building to the right. Did the Ponaganset River located behind it give it a nice cool breeze?

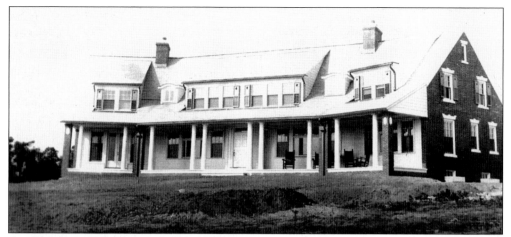

As this photograph shows, William H. Joslin was a wealthy man. Early in 1924, he decided to build a new home on Fields Hill Road. This was to replace the one in the village about to be destroyed. He hired Earl R. Knight, a building engineer, to build it on top of the hill near Clayville. It was the Joslins summer home until 1947, when they moved in permanently. It was not until July 1925 that the final settlement was awarded to the Joslin Manufacturing Company of $1,293,750 and another $431,250 for the Scituate Light and Power Company, which Joslin also owned. By November 1925, the reservoir was being filled. This estate was occupied by Joslin family members until 1989, when they could no longer afford the huge tax burden. In 1990, the City of Providence condemned it, again by eminent domain, and auctioned all remaining articles. Because of extreme vandalism over the years, in 1998 the city burned all buildings, trucked away the remains, filled in the foundations, and today there is no sign the Joslin estate ever existed. Below is the front view of the barn Knight also built, as the sign on the railing above the entrance door announces. This photograph was taken at 3:22 p.m. late in 1924 or early 1925.

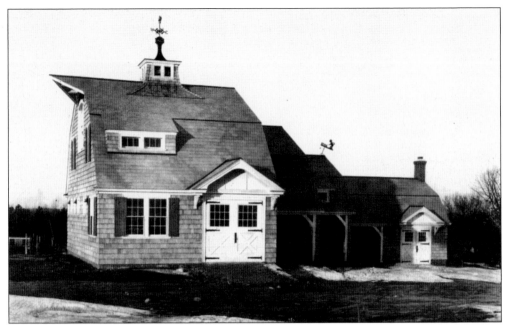

Although William H. Joslin had built a beautiful house and barn no estate would be complete without a carriage house. This is the carriage house he had built to the right of the barn. The horse on top of the weather vane records the wind was blowing from the northeast this cold winter day.

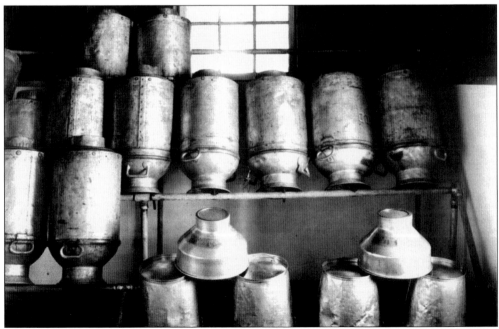

One can tell from the condition of these milk cans that Joslin was a stickler on cleanliness. The cans state they are Hood cans from the Hood Dairies. Was Joslin a supplier for the Hood Dairy Farms? This was quite a big change from running mills to operating a dairy farm.

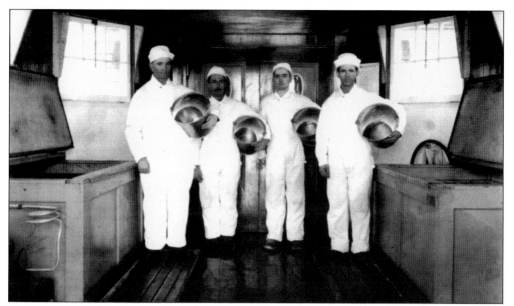

Joslin's men are prepared to do the morning and evening routine of milking the cows. There were no mechanical means of doing it at the time. It was all done by hand every day. There were 30 dairy farms condemned and lost to the state of Rhode Island forever. It appears Joslin took advantage of the situation and funded this elaborate setup to be built.

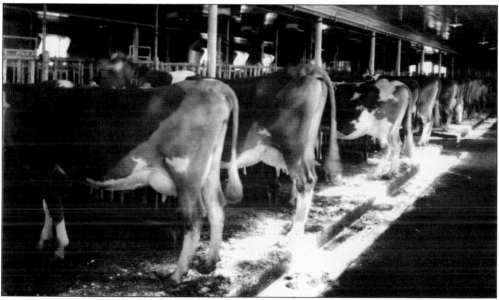

It appears the cows are in from the fields and also ready. They are lined up to be fed and milked. Barns were either built up a little or into a hill so there could be an area underneath. The floors were made of planks and the light ones right behind the cows' feet are hinged to open. When the stalls were cleaned the manure would be shoveled down below. In the spring the manure would be spread on the farmers' fields and plowed into the ground during planting to fertilize his crops.

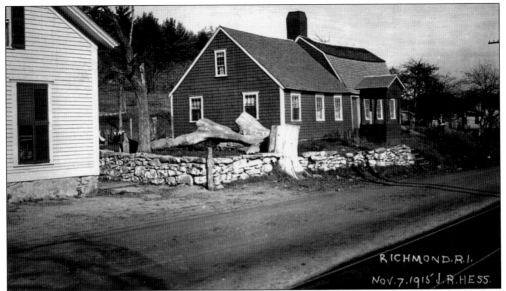

The Angell family lived here just up Plainfield Pike from the Joslins. Their daughter is sitting on the stump to the right of the house, keeping a watchful eye on "the man from the city," as John R. Hess came to be known. Again he was out snapping pictures on this clear Sunday morning of November 7, 1915. To the right of the road lie the tracks of the Providence to Danielson Railway system.

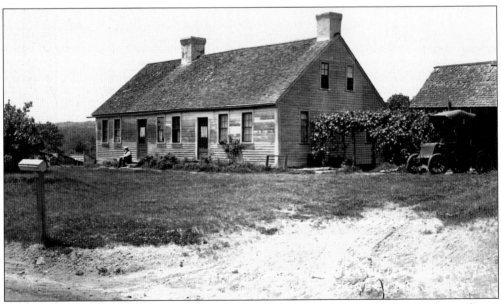

Ezra R. Knight and his wife owned this duplex located on Plainfield Pike west of Richmond near Tunk Hill Road. Could that be Ezra sitting on the step smoking his pipe and wearing his vest and cap after having gone to church this sunny Sunday, June 18, 1916? The automobile is from the early 1900s, as it does not have a steering wheel only a lever for steering.

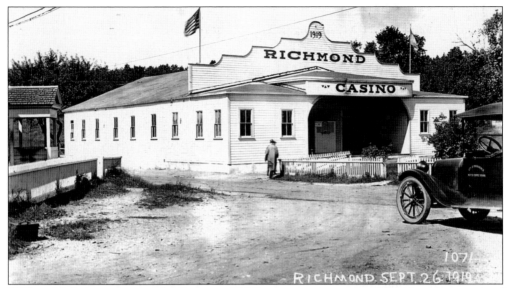

William H. Joslin, owner of the Richmond Mill, was given notice in 1916 of condemnation of the area. In the spring and summer of 1919, he chose to build the Richmond Casino knowing that it would be torn down. It is said he was heard saying, "If we are going to lose our village, we may as well have fun in the meantime." It was a beautifully constructed dance hall. Bands would play on Friday and Saturday nights and folks would come from all around to have a good time after a hard week's work. The above photograph was taken looking northeasterly from near the southwest corner of Plainfield Pike and the Rockland to Richmond Road on Wednesday, September 26, 1919.

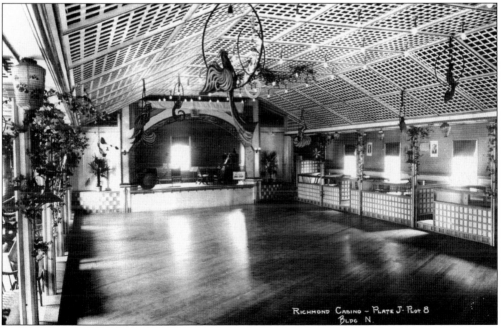

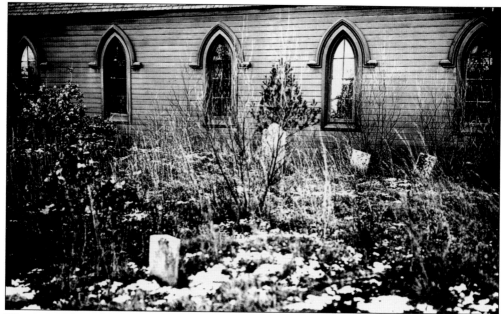

They rested here for decades beside their beloved Rhode Island Episcopal Church. However, when this photograph was taken in December 1915, their future was doomed. They were to be moved, and the church torn down and taken away, or they all would be under 50 feet of water when the reservoir was filled. This site was located on the south side of Plainfield Pike near Richmond.

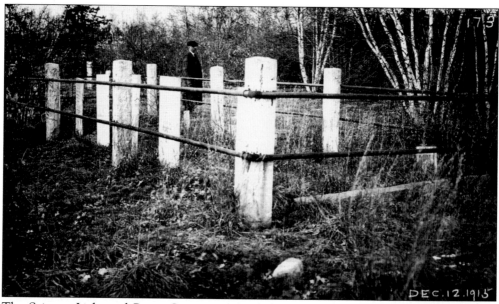

The Scituate Light and Power Company owned the site of this burial ground where seven graves were removed in 1916 to be relocated. The cemetery was located on the Rockland to Richmond Road near Richmond. John R. Hess took this photograph on a cold Sunday, December 12, 1915.

Five

THE LOST VILLAGE OF KENT

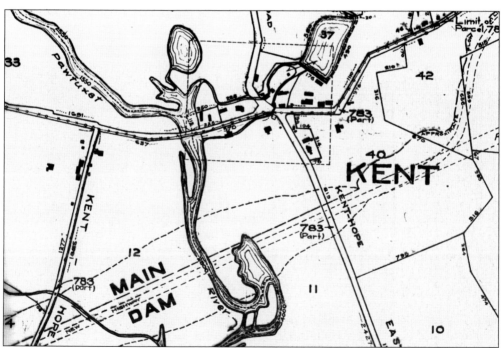

This 1916 map shows the Pawtuxet River flowing right through the village of Kent, and the site that was chosen to build the 3,200-foot dam to create the Scituate Reservoir. It took almost a year to fill but would eventually bury the remains of the village under more than 80 feet of water. It was known as Kent Dam until 1949, when it was dedicated to the Honorable Joseph H. Gainer, the presiding mayor of Providence during the planning and building of the project.

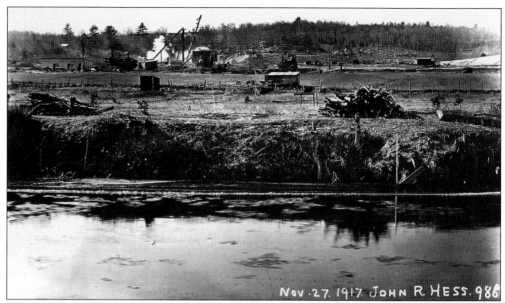

Nov. 27. 1917 JOHN R. HESS. 986

This photograph was taken standing on the east bank of the Pawtuxet River just outside the village of Kent, looking west. Any land that was to be flooded needed to be cleared of trees. The brush was piled and burned, the logs piled and sold, and the stumps dug out and taken away.

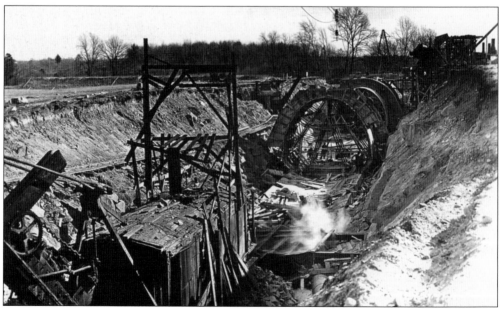

This will be the conduit beneath the dam to allow a flow of water to the Pawtuxet River for the mills downstream. The city made an agreement with mills to allow 70 million gallons to flow downstream daily if the reservoir were full by June 1. Otherwise 65 million gallons would be released until it was full. In the lower left corner is a 60-ton steam shovel hard at work. To the right on top of the hill is an 18-ton Osgood steam shovel converted for use as a crane.

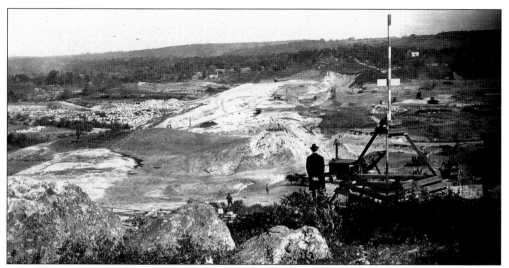

This is looking northeasterly from the west end of the dam location. The village of Kent can be seen just above the middle of the photograph. The dark line running across the center is the Pawtuxet River. By December 4, 1917, the land had already been striped of trees in this area.

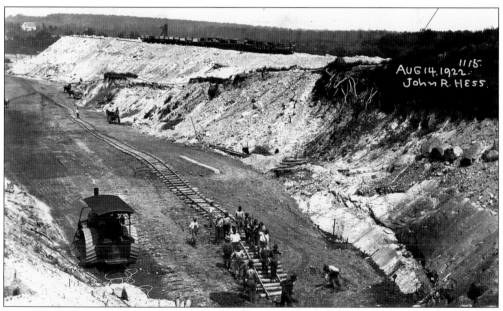

A standard-gauge two-and-a-third-mile railroad spur was constructed in 1921 over a right-of-way, a portion now owned by the author, from the village of Jackson through Hope village to the site of the dam. The contractor leased a 54-ton, six-wheel steam locomotive with five flatcars to haul all equipment, coal, cement, and other supplies to be shipped directly without double handling. A smaller train used on site can be seen on top of the mound of dirt where the dam was being built with new tracks being laid below. The following verse is from "The Old Railroad" by Helen O. Larson: "It took a long time to build the dam, ten years I've heard it say / And the little locomotive would run, each and every day."

This property belonged to James King. His homestead was located on the Bald Hill Road. This photograph shows his home and barns. He may have had a sawmill in one of the barns, as it appears he has cleverly stacked newly cut boards with air spaces between them so they could dry.

This is also King's farm. The silo on the barn, which was used to store grain, indicates that he must have also had livestock. At the time, almost everyone had at least one cow to provide milk for the family table. However, a silo of that size would certainly mean a herd larger than one cow.

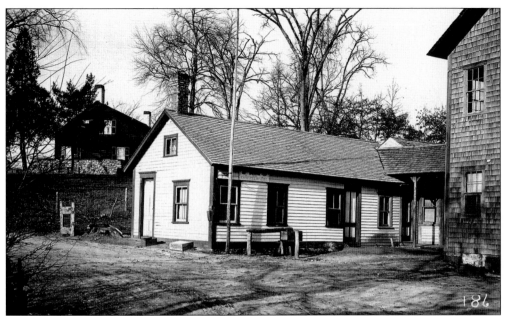

J. A. Cahoone owned three and a half acres at the intersection where North Scituate to Kent Road, Bald Hill Road, Kent to Coventry Road, and Kent to Hope East Road all joined together. His confectionary store is pictured above, and the mill and shop next door are shown below. The water to power the mill was acquired by digging a trench from the Cahoone Mill Pond at the upper part of his property down to his mill before flowing into the Pawtuxet River. When Cahoone built his house, he actually built it right over the trench. Both photographs were taken on December 22, 1915. The one above shows a flagpole and also a hitching post to tie ones horse to while shopping. The one below shows a very nice sled wagon used to go to town in the winter snow.

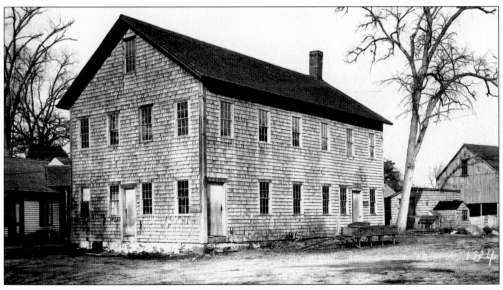

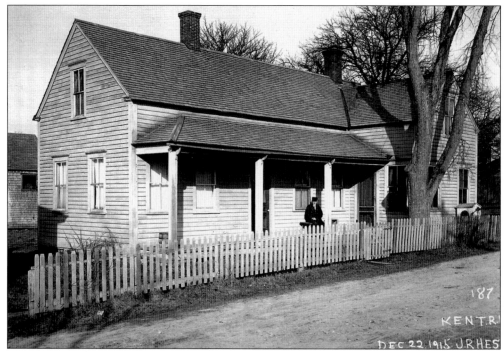

J. A. Cahoone is sitting on his porch keeping a watchful eye on John R. Hess, who is taking his picture. The well is conveniently located right outside the door as well as the house being built right behind this large tree. The house was built on the northeast corner of the lot on Bald Hill Road.

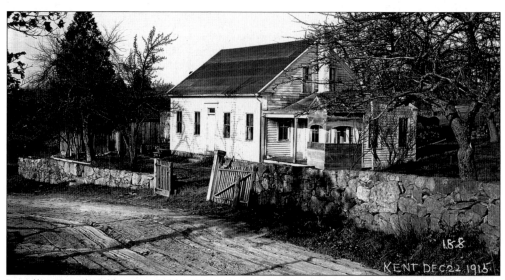

Lewellyn Yeaw lived here on Bald Hill Road until the city took it over for an office headquarters of the section engineer. Kent was the first village to be torn down as it was the location designated for the dam. If the houses were not torn down they were used to house the workers of the project.

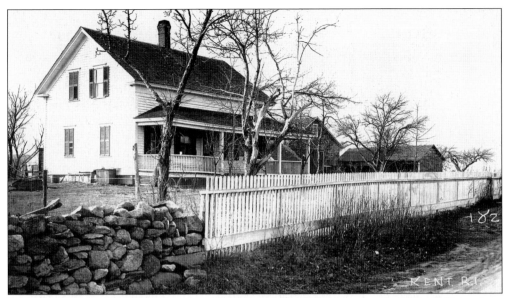

I. A. Kingman and his family lived on this 12-acre farm on the west side of North Scituate to Kent Road. Kingman's neighbor W. F. Potter lived on about an acre just down the road on the east side. They had been friends many years. The following verses are from "They Condemned the Land" by Helen O. Larson: "They condemned the land, and told us we would have to move away / We were so sad and frightened, on that dreadful day. Our neighbors moved, one each day / It was sad to see them go, as they moved away. We didn't know, just where we would go / The city bought the land, So it had to be so." These photographs were taken on December 22, 1915.

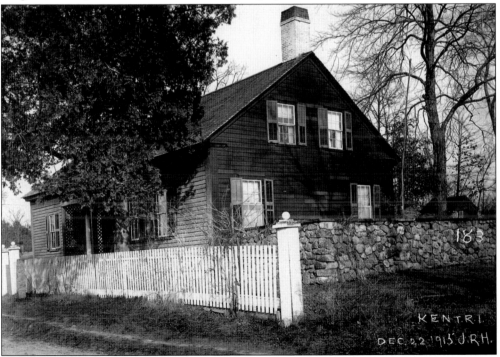

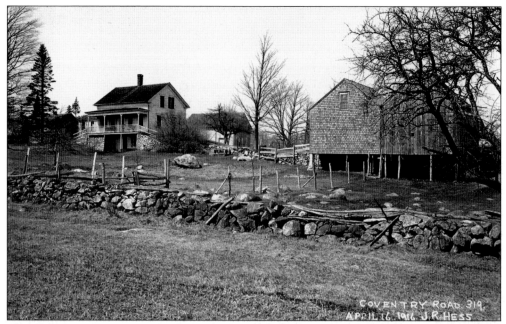

This farm owned by Manford E. Yeaw was located north of the Kent to Coventry Road. These are typical barns built up high so underneath would be readily accessible come spring and planting time. Yeaw would be able to back his manure spreader under easily to be loaded with manure deposited from the stalls above during the winter. He used it to fertilize his fields before planting.

L. Yeaw has the same idea even though it appears to be a tight squeeze. However the results would be the same. His farm is located at the junction of Kent to Coventry Road and Kent to Hope East Road. Again John R. Hess is out snapping pictures on this Sunday, June 18, 1916.

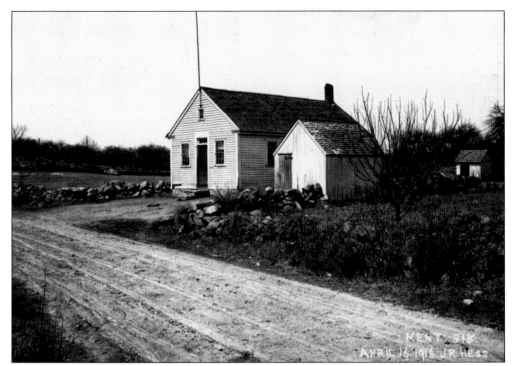

The following verse is from "If I Could Go Back" by Helen O. Larson: "The little one room school house where we went each day / Was soon demolished and the lumber trucked away." The school was located on the Bald Hill Road just outside of the village. It appears the owner of the land to the west of the school maintained a very large orchard, maybe apples.

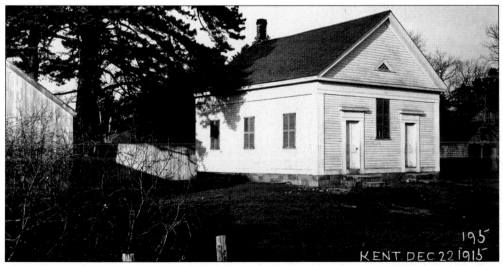

This Christian Union Church was organized on March 7, 1877, and located on the outskirts of Kent Village. It was a very active church with a strong congregation. This was a time when everyone knew their neighbors and worshiped together on the Sabbath. Rev. Daniel R. Knight was pastor.

Antoine Lux and his wife lived here on Bald Hill Road a little east of the village. These folks were told recently the city was building a reservoir and taking their property and that they would have to move. One wonders why John R. Hess was out on Sunday April 16, 1916, taking pictures.

Sarah A. Rogers lived just east of the Lux family on the opposite side of Bald Hill Road. This was a two-story house with an addition. There was an outside entrance to the basement as stairs inside were very rare. The outbuildings are to the right of the house, and some kinds of coops are to the left.

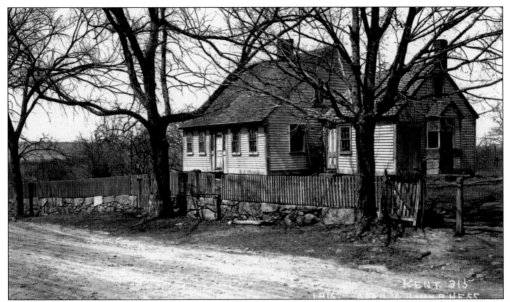

This photograph, taken on April 16, 1916, is of John C. Smith's homestead. He and his family lived just around the corner from Rogers on Bald Hill Road. It appears at one time an addition was added including another fireplace, their only source of heat. There were three very nice maple trees in front to shade the house from the bright sun of summer as the house faces south.

William E. Barden maintained this well-kept home on a half-acre lot in the center of the village. It was located at the intersection of Kent to Coventry Road and Youngs Road. The driveway on the left is leading to one of his two barns. The second barn was located directly behind the house.

Edgar S. Yeaw lived on a small lot on the west side of Kent to Hope East Road. His neighbor John W. Powell (below) lived next door. When these photographs was taken on June 18, 1916, it appears both families had moved on. The following verses are from "The Land Was Condemned" by Helen O. Larson: "All the buildings and the land were condemned one day / And that was the reason we had to move away. Friends and neighbors, had to move too / You could never know the heartache, unless it happened to you." The grass has grown up, and there are no curtains in the windows. They are just waiting to be torn down and carried away.

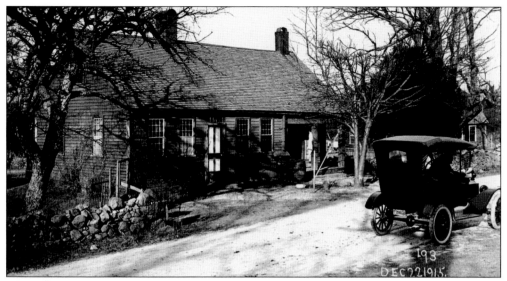

The following verse is from "If I Could Go Back" by Helen O. Larson: "The evening shades are falling, the sun is going down / Tonight I'm living in the past, dreaming of my home town." F. B. Hutchins lived in this house sporting two fireplaces on a half-acre lot on the north side of Bald Hill Road. He owned these two barns below on 12 acres across the road with a 1,231-foot frontage. This was a nice size farm on the very outskirts of Kent Village. The Hutchins property would become the site of the dike to be built on the east side of the dam. It also was to occupy the extension of the road traveling across the dam and connecting to the new North Scituate to Hope Road, which is now known as the North Road. Both photographs were taken on December 22, 1915.

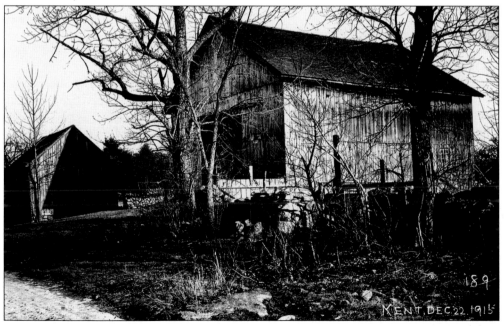

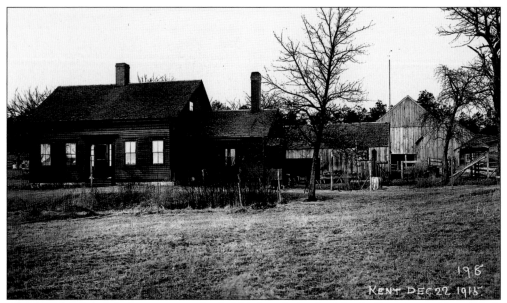

Clinton H. Johnson's farm was set back 300 feet from the North Scituate to Kent Road. His 45 acres, including a three-acre pond, stretched over 1,000 feet all the way west to the Pawtuxet River. This was very productive land for his herd of cows. All his barns were close by the house.

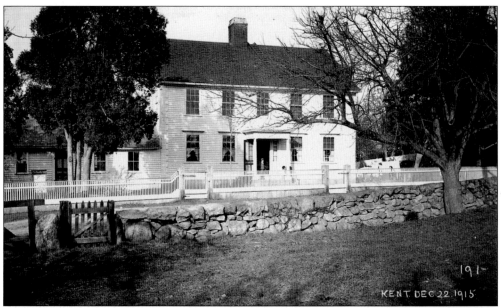

James King and his family lived in this beautiful home in the center of the village on Bald Hill Road. They owned 23 acres with Kent Brook running through the center of it. The following verse is from "The Villages" by Helen O. Larson: "One day a man from the city, came to our village to say / They had bought all buildings, to be torn down and the lumber would be taken away."

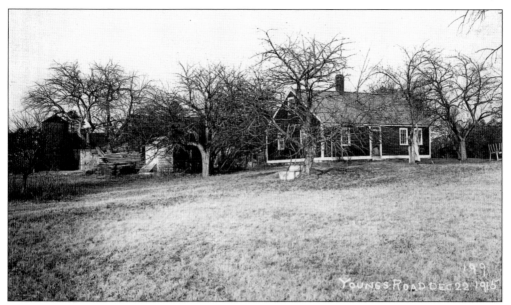

Located just outside of Kent Village is E. A. Salisbury's 38-acre farm that had 900 feet of frontage on Youngs Road. The property bordered Knight Brook to the south giving Salisbury plenty of water and lots of grazing land for his cows. The barn and silo can be seen to the left of the picture.

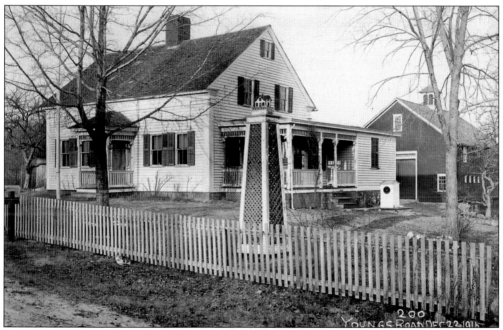

Just down Youngs Road on the opposite side M. C. Young maintained 66 acres. As can be seen above, Young took pride in the appearance of his house and barn. All the foundations of the homesteads that were on Youngs Road are now under water, never to be seen again.

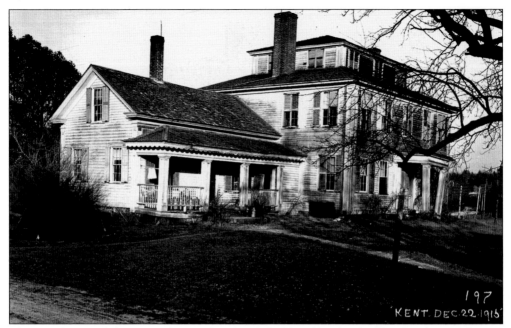

This was the grand three-story home of Arthur S. Field and his family. They lived on 39.62 acres bounded on the north by the Kent to Coventry Road as seen by the telephone poles to the right of the house in the photograph above. The Pawtuxet River followed his land on the east, and on the west, his land butted the Kent to Hope West Road shown below. It appears on December 22, 1915, his home was in bad need of attention by the looks of the columns in the front.

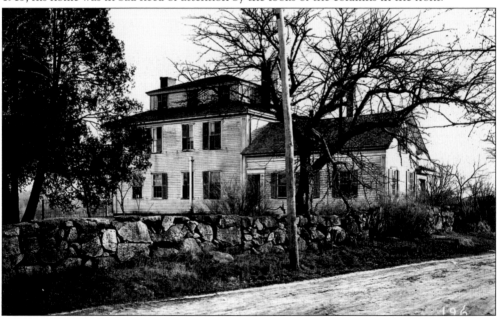

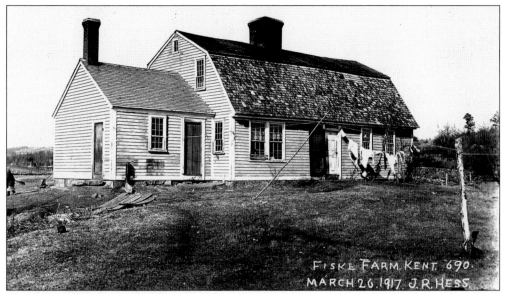

This was the residence of Hannah M. and Harden I. Fiske. Their farm was located south of Kent on the Kent to Hope East Road on the east side of the Pawtuxet River. Below is the family cemetery located on their farm. Spring had just been recorded on the calendar for this Monday, March 26, 1917, and summer would soon arrive. Their resting had to be interrupted as they were moved to the New Rockland Cemetery in Clayville, hopefully to their final resting place. The two headstones close to the railing (below) read "Russell S. Young, born, July 17, 1839, died, March 30, 1895," and "Eliza A., wife of, Russell S. Young, born Nov. 7, 1847, died Jan. 31, 1908." The Fiske farm consisted of 179 acres divided on both sides of the road.

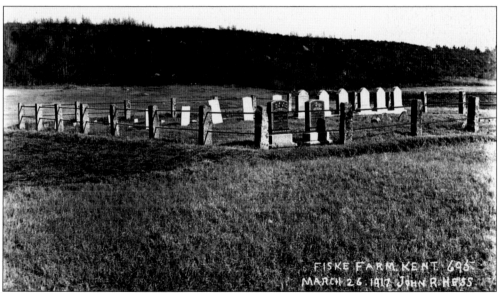

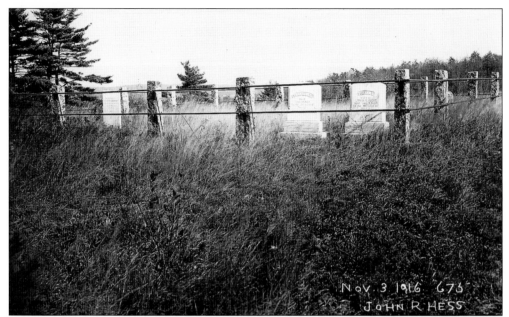

This cemetery was located on Lyman A. Knight's property. This photograph was taken on the overcast Friday of November 3, 1916. It appears it was sitting high on a hill and out of the flood area. Therefore it did not need to be relocated. It was south of Kent on the Kent to Coventry Road.

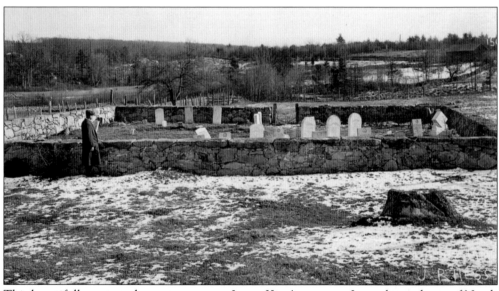

This beautifully protected cemetery was on James King's property. It was located east of North Scituate to Kent Road near Kent Brook. King had 23 acres surrounding the cemetery. Six of the headstones have the same unknown symbol engraved at the top. The beautifully crafted walls now lie beneath the reservoir. The following verse is from "Days of Destruction" by Helen O. Larson: "The city lawyer tried to buy one elderly man's home / He said I was born here and I'll die here, So he cut his throat and died in his bedroom alone."

Six

THE FORGOTTEN ONES

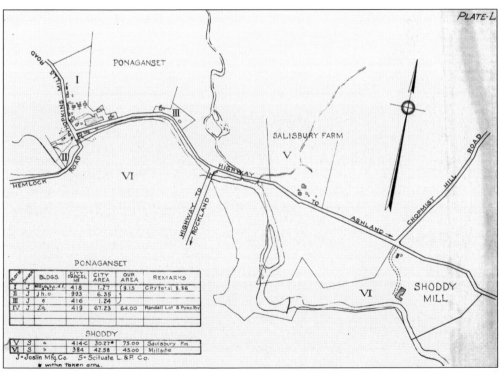

PLOT NO.	OWNERS	BLDGS.	CITY PARCEL N°	CITY AREA	OUR AREA	REMARKS
I	J	Mill,o,b,c,d,r	418	1.27	9.15	City total 8.86
II	J	j,h,o.	993	6.35		
III	J	e	416	1.24		
IV	J	J'q.	419	67.23	64.00	Randall Lot & Pono Riv

SHODDY

V	S	a	414-C	30.27*	75.00	Saulsbury Fm
VI	S	b	384	42.58	45.00	Millsite

J = Joslin Mfg. Co. S = Scituate L. & P. Co.
* within taken area.

This 1895 map indicates that when traveling north on the Highway to Rockland it intersected with the Highway to Ashland. If one traveled east on this highway to the junction of Chopmist Hill Road, one would come to a little hamlet know as Shoddy. If one were to turn west at the Highway to Rockland intersection, it would take one to the village of Ponaganset. Both are only memories now along with Wilbur Hollow and Saundersville.

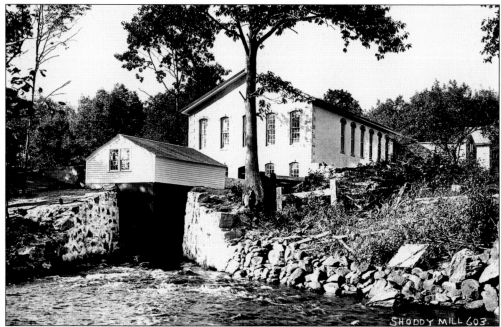

This side and rear view of the well-maintained Shoddy Mill, built in 1866, shows the wheelhouse that generated power to run the mill. After the water had passed through the wheelhouse, the tailrace returned to the Ponaganset River. This photograph looking in a northwesterly direction was taken on October 10, 1916. The photograph below shows the braiding room machines that would weave scraps of shredded cloth together with wool fibers to create shoddy yarn. The first shoddy yarn was not manufactured until 1874. It appears all is quietly waiting for the demolition crew.

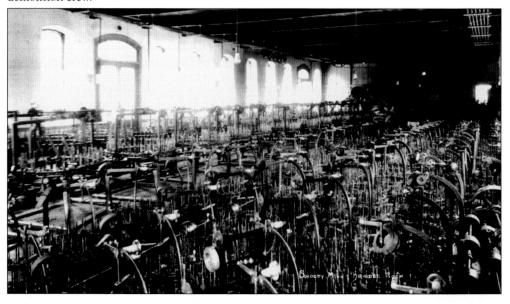

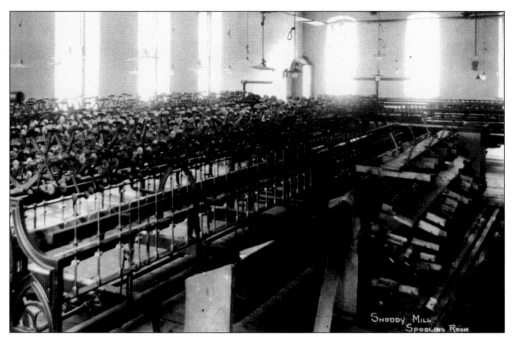

Shoddy machines were invented in the United States and the first Shoddy Mill recorded started in Ulster County, New York. This is a photograph of the spooling room of this Shoddy Mill. Their job being done, they will now be dismantled and taken away.

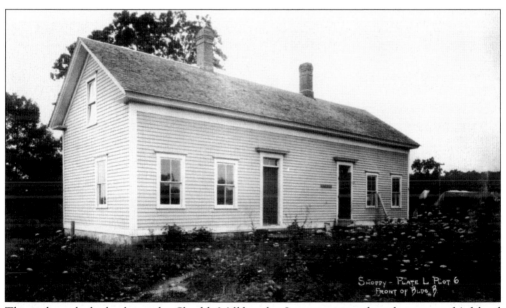

This is the only duplex located at Shoddy Mill hamlet. It was positioned on the corner of Ashland to Ponaganset Road and the driveway leading into Shoddy Mill. Across the road was Chopmist Hill Road intersection. It appears the family on the left has vacated, but on the right, there are curtains in the windows and something hanging on the clothesline.

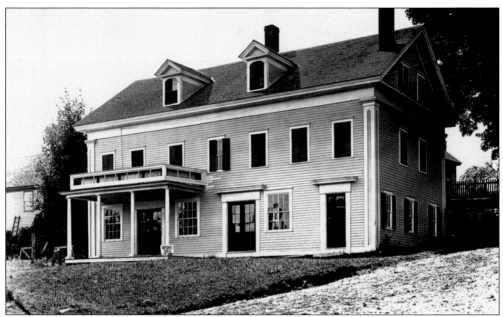

Eliza A. Barden lived in this beautiful house with a store downstairs. It was located on Hopkins Mills Road around the corner from Ponaganset Village at the mouth of the Barden Reservoir. The City of Providence condemned the area and paid the Barden Reservoir Company $110,290.28 on September 20, 1922. It stores 853 million gallons of water and is used to regulate stream flow on Ponaganset River.

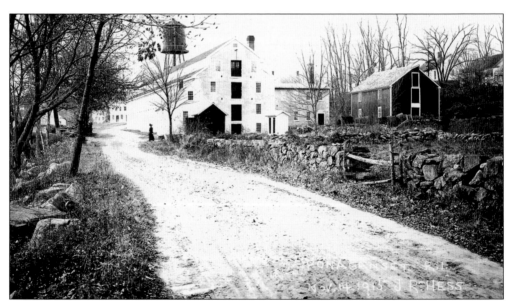

The Ponaganset Mill was built right alongside the Ponaganset to Ashland Road. It appears it had four stories with the first floor being partially beneath grade. An interesting object here is the outhouse with his and hers separate sides. Could that possibly be where the lady is headed for?

This is the trench bringing water to the headgates from the Barden Reservoir to supply power for the Ponaganset Mills built in 1827. The Joslin Manufacturing Company acquired the buildings on December 18, 1899. In 1905, they installed a water tower and sprinklers because of so many mill fires. In 1909, they installed a hydroelectric plant. After a long court battle, the city finally settled with the Joslins in 1925. The photograph below, taken on November 14, 1915, shows what a well-maintained mill this was. It also impressively presents the water tower as one entered the property. There were a number of buildings on the premises. The following verse is from "Country Memories" by Helen O. Larson: "The city bought the land and all the buildings too / You could never know the heartbreak unless it happened to you."

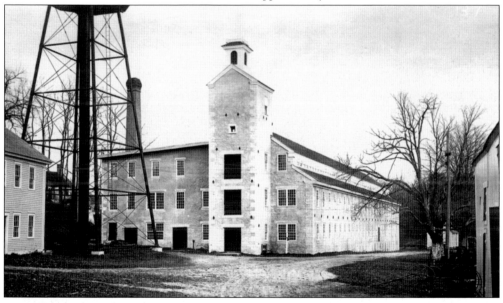

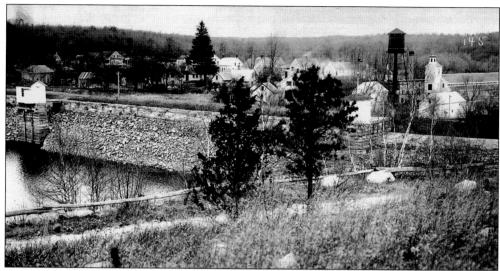

This photograph, taken on November 14, 1915, places the Barden Reservoir on the left with the gatehouse in the center of the dam. The Ponaganset Mill is to the right with its water tower standing proudly. The Hopkins Mills Road ran though the village to connect with the Ponaganset to Ashland Road. The village was condemned and torn down for being in the watershed area.

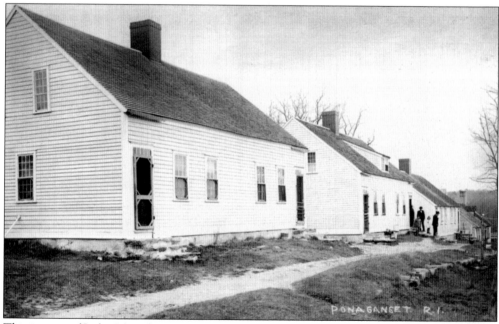

This is a row of Joslin Manufacturing tenement duplexes in the village. Considering the mother, father, son, and daughter are dressed in their Sunday best on this Saturday, November 14, 1915, could they be going to attend a wedding? It appears they are headed down to the center of the village.

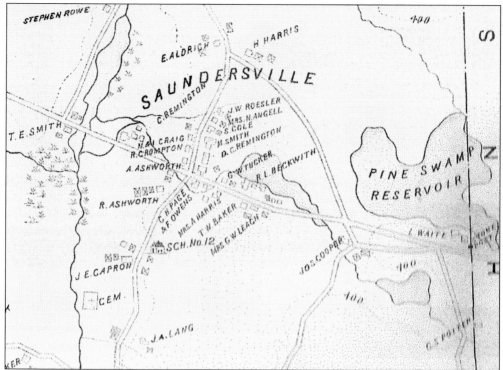

This 1895 map depicts the small village of Saundersville located at the crossroads of the east to west Saundersville Pike and the north to south North Scituate to Kent Road. The first cotton mill, Saundersville Middle Mill (pictured below) was erected in 1828–1829 and hence the village grew around it, including their own school. These lonely walls were all that remained after fire destroyed it in 1905.

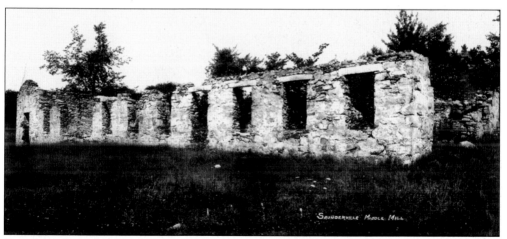

Saundersville had three mills, the Upper, Lower, and Middle Mills. Issac Saunders owned the Upper Mill, built between 1833 and 1836, until Ella M. Joslin, grandmother of William H. Joslin, bought the property. They employed 12 males and 13 females, producing 280,000 yards of print cotton cloth annually. The wages per month were males $255 females only $166. In 1897, it was destroyed by fire. The Lower Mill built in 1839 was also destroyed by fire in 1902.

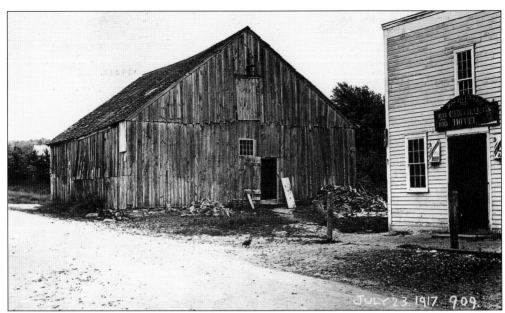

Joseph Brochu proudly stated on the plaque over the entrance he was the proprietor of the Central Hotel. It also advertises ales, wines, liquors, and cigars were available at his establishment. The two signs on either side of the door shows Narragansett Lager or Narragansett Ale were available from the Narragansett Brewing Company located in Cranston. The hotel had a great location at the intersection of Saundersville Pike and North Scituate to Kent Road. The Scituate School District No. 12 schoolhouse (below) was located in Saundersville on North Scituate to Kent Road just south of Saundersville Pike and the village.

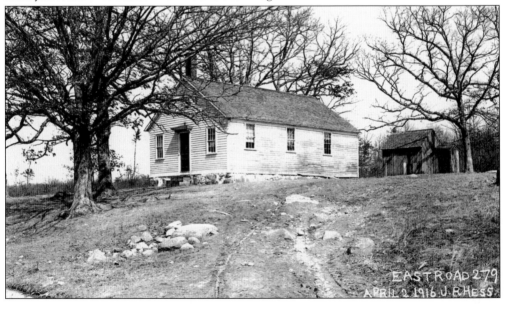

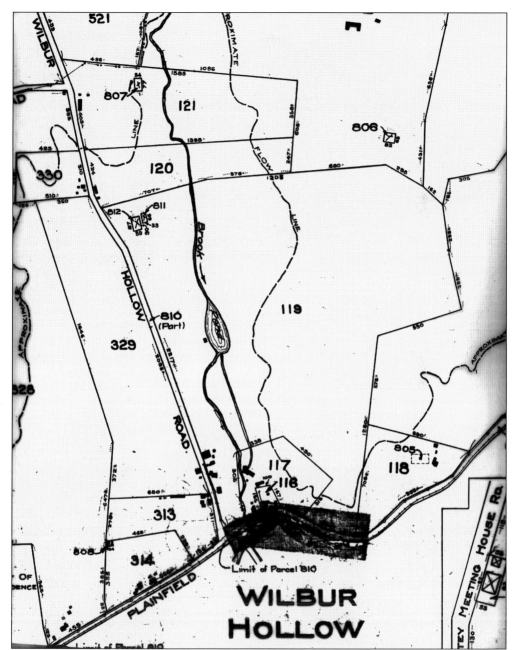

In 1916, Wilbur Hollow Road traveled from the Ashland to Ponaganset Road all the way south, ending just west of South Scituate at Plainfield Pike and the hamlet of Wilbur Hollow. It was made up of mainly farmers even though some of the folks worked in the nearby mills, Richmond being to the west and South Scituate just to the north. Even Ashland was only a short distance further north. There was plenty of work to be had before the Great Depression set in.

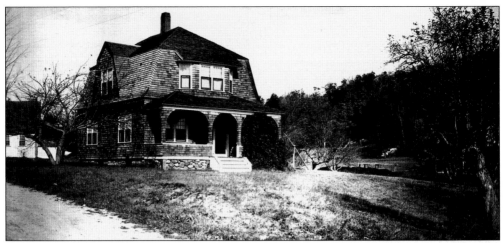

William H. Bowen, M.D., lived with his family in this lovely summer residence. He was the man everyone in these parts relied on when they were sick and home remedies were not curing it. This was a time when doctors actually came to their patients, making what was called at the time a house call. The family farmhouse can be seen to the left of this photograph, which was taken on Sunday, November 7, 1915.

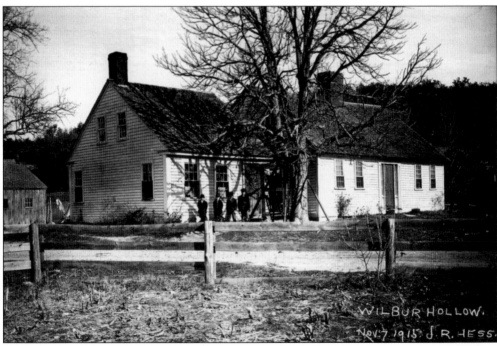

Dr. Bowen's boys are dressed in their Sunday best as they pose for John R. Hess to take their picture. The farmhouse and the summerhouse next door were both located near the junction of Wilbur Hollow Road and Plainfield Pike. Notice how the people built their homes behind great big oaks or maples to shade the house; this was their means of conditioning the air.

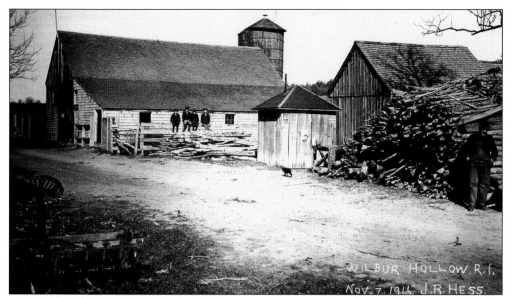

The Bowen boys are sitting on top of the fence with their feet on the pile of logs and their eyes on Hess as the family dog approaches them. Could that be the doctor standing to the right of this photograph by the stack of wood also keeping an eye on Hess on this Sunday, November 7, 1915?

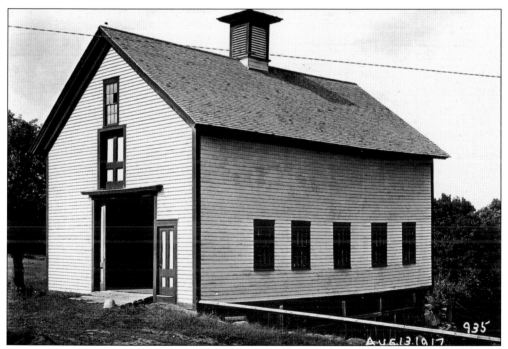

Benjamin Wilbur owned this barn located on Plainfield Pike west of Richmond and a little west of Wilbur Hollow opposite Wilbur Pond. It was beautifully maintained and a great example of the access area under the barn for loading the manure to fertilize the crops when planting in the spring.

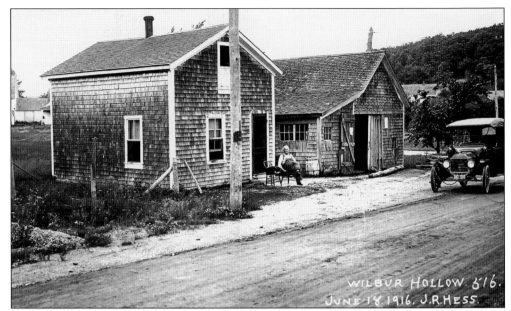

It appears G. A. Kennedy is relaxing in front of his house and shop on this lovely Sunday afternoon, June 18, 1916. His homestead was located at the junction of Plainfield Pike and Wilbur Hollow Road. The following verse is from "The Homestead" by Helen O. Larson: "Oh! That homestead, of so long ago / A place where happiness lived, God willed it to be so."

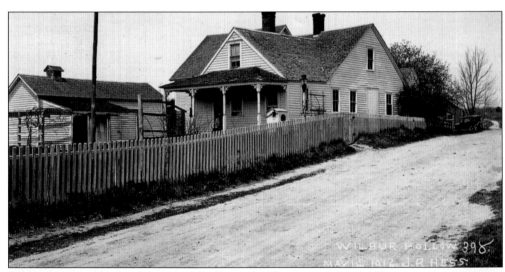

This property is also listed as owned by Kennedy. This house appears older than the one above because of the additions. Maybe this is where he grew up as a child with the house being owned by his father. It was located at the junction of Ponaganset Road and Wilbur Hollow Road. Note the well in the front yard, the flagpole, and John R. Hess's car parked on the corner. This photograph was taken on Sunday, May 14, 1916.

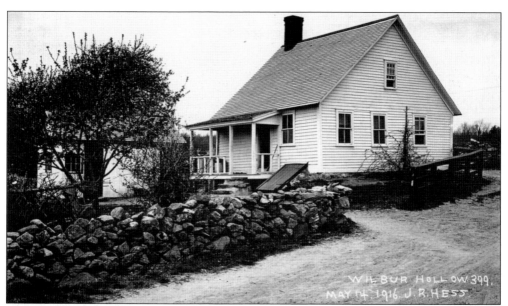

Edward Lawton lived in this very comfortable cape (above) on Wilbur Hollow Road just south of River View Road. Note the slanted door outside going into the cellar. When children got mad or upset with a friend they would sing the following rhyme. The following verse is from "A Friend" by Helen O. Larson: "I won't let you holler down my rain barrel, I won't let you slide down my cellar door, I won't let you play in my yard, I won't be your friend anymore." Of course, the friends always made up. This photograph was also taken on May 14, 1916. The farm below was owned by G. K. Whitman and located on Wilbur Hollow Road a little north of Plainfield Pike. Hess was out again on this Sunday, May 14, 1916, recording all the buildings that were to be taken by the city.

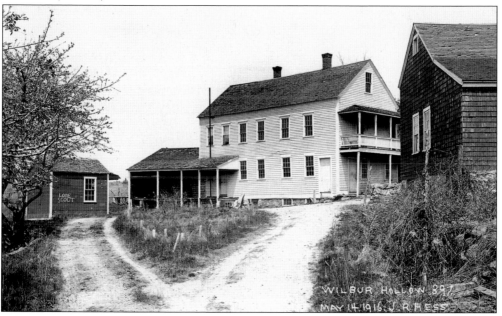

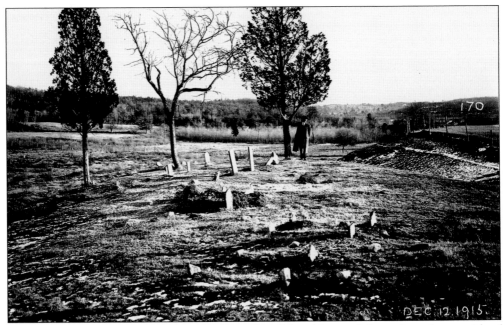

This all-but-forgotten small cemetery was located on Edward Lawton's farm along the east side of Wilbur Hollow Road shown to the right in the photograph. It was opposite the River View Cross Road. This photograph was taken late Sunday afternoon, December 12, 1915.

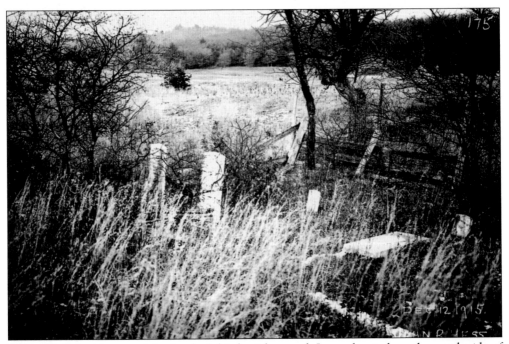

Henry M. Schmidt owned the land of this burial ground. It was located on the north side of Plainfield Pike near Wilbur Hollow. Wilbur Hollow was at the junction of Plainfield Pike and Wilbur Hollow Road. It was named after the Wilbur families that lived in the local area.

Seven

THE SCITUATE RESERVOIR
THEN AND TODAY

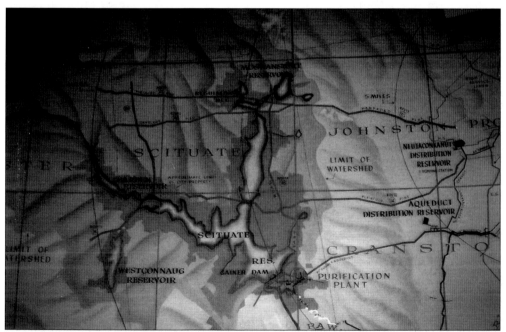

This map of the Scituate Reservoir and surrounding area hangs on the wall of the purification plant's lobby. It shows the Ponaganset Reservoir in the northwest corner flowing into the Barden Reservoir then into the Scituate Reservoir. The Westconnaug Reservoir and River joins the reservoir from the west. From the north, the Moswansicut Reservoir flows into the regulating reservoir then over the Horse Shoe Dam spilling into the Scituate Reservoir. At the southern end is Gainer Memorial Dam, with water flowing to the purification plant and also feeding the Pawtuxet River. (Author's collection.)

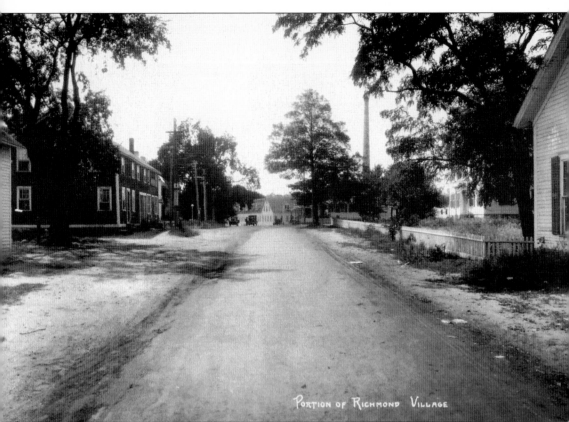

PORTION OF RICHMOND VILLAGE

This photograph was taken looking west on Plainfield Pike approaching the village of Richmond. The road would be headed down toward the Ponagansett River and the location of the Richmond Mill Complex. The smokestack of the mill can be seen on the upper right side of the photograph. This was a quiet New England village where most people obtained their living from the mill. The two men on the doorstep may be pondering as to why someone is taking a picture of their village. The following verse is from "My Hometown" by Helen O. Larson: "The buildings were demolished, the city bought them one day / To build the Scituate Reservoir, they took our beloved villages away." It is difficult to comprehend that this entire area is now 50 feet below the surface of the Scituate Reservoir.

This photograph is of the abandoned portion of Plainfield Pike looking east toward the site of the village of Richmond. The pike traveled down the valley, across the Ponagansett River, passing the Richmond Mill Complex, intersecting with the Richmond to Rockland Road, and passing through the village before climbing out of the valley on its way to Providence. (Author's collection.)

This same abandoned portion of Plainfield Pike as above now just leads to the waters edge and then disappears beneath the surface of the water. Some 50 feet below the surface at the center of the reservoir lays the remains of the Ponaganset River, still flowing silently, even though it lost its name when swallowed up by the rising waters of the Scituate Reservoir. The drowned river has quietly kept the village of Richmond company for over 80 years. (Author's collection.)

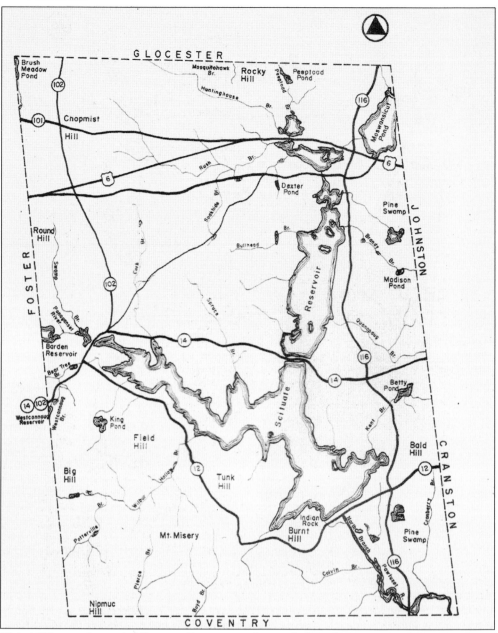

This 1980 map shows the Scituate Reservoir today, including the network of the 26 miles of new roads that were constructed to replace the abandoned ones. It shows Route 12 that crosses over the dam where the village of Kent was located replacing Bald Hill Road. Route 14 crosses over the causeway where the village of Ashland was located and is now the new Plainfield Pike. At the north end of the map on the old Route 6 east of Dexter Pond is the location of Horse Shoe Dam. The alternate Route 6 was later constructed to divert heavy truck traffic around the village.

120

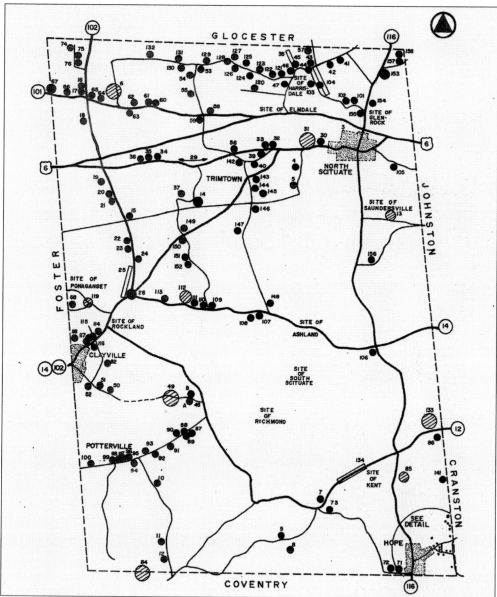

This map of Scituate locates the five villages that were lost forever, Rockland, Ashland, South Scituate, Kent, and Richmond. It is an early drawing after the dam was built at the site of Kent Village. Also shown are the 26 miles of new roads that were constructed around the perimeter of the reservoir to replace the 36 miles of roads that were abandoned. The village of Hope located in the lower right corner was spared being below the dam and flood area. Likewise the village of North Scituate was only partially taken because of the building of the Horse Shoe Dam to create the Regulating Reservoir. This was designed and built to store water to be released to the lower reservoir as needed. It was also part of a flood control plan therefore named the Regulating Reservoir.

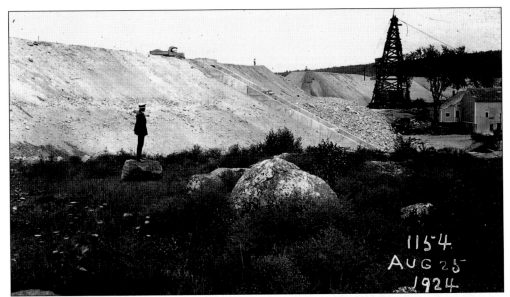

This August 25, 1925, photograph is looking northeasterly from the shoreline. It depicts the building of the causeway, the culvert that the Moswansicut River will pass through, and the village of Ashland still hanging in there. There was just over one year left before the water would rise.

This photograph is looking east from the west end of the causeway as it reconnects with land. The village of Ashland is only a memory as its remains are sleeping 37 feet beneath this heavy blanket of snow and ice on this cold day in January 2009. (Author's collection.)

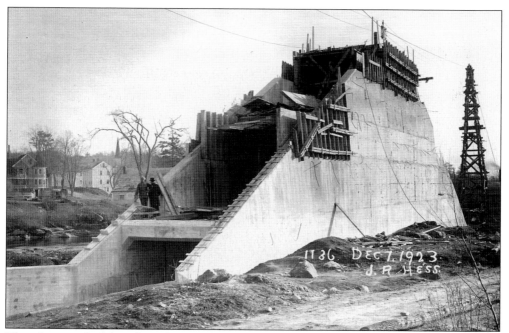

This photograph shows the culvert under construction through which the Moswansicut River would soon flow. It was taken on December 7, 1923, looking southeasterly from the north side of the causeway. One can still see the village of Ashland to the left. It must have been awful for the people knowing this would be flooded in less than two years.

This close-up of the causeway shows a view of the conduit under the causeway. As the water line shows on the stones, the reservoir at this time is about seven feet from being at capacity. With the Ponaganset, Moswansicut, and Westconnaug Rivers flowing into the Pawtuxet River just one good rainstorm and the reservoir will be filled to the brim. (Author's collection.)

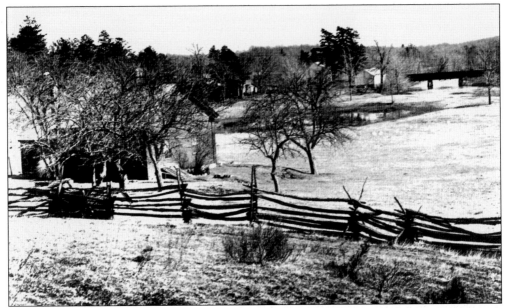

C. H. Johnson had a lovely view of the Pawtuxet River and the bridge carrying Bald Hill Road. The village of Kent would have been to the left of his property. Kent was the first village to meet its demise because it was the location of the dam. The work began to the right of the Pawtuxet River therefore there was no need to divert the river at the beginning of the project. (Courtesy of Shirley Arnold.)

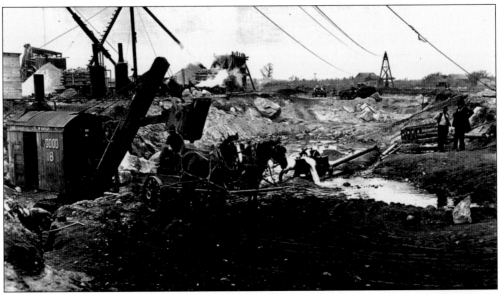

This photograph was taken from the west side of the site for the dam looking north. Excavation was done by steam shovel and loaded into wagons drawn by two horses to another location. The topsoil was striped by a hand gang, as can be seen in the background on top of the cut out where the wagon is being loaded. The concrete plant has been built on top of the hill on the left.

This photograph is looking across the face of the dam in an easterly direction. The older people of Scituate know this as Kent Dam, even though at the far end of the dam there is a statue that states it is the Gainer Memorial Dam. Joseph H. Gainer was the mayor of Providence when the dam was constructed therefore it was dedicated in his honor on October 15, 1949. The downstream face of the dam is faced with grass to protect against erosion. (Author's collection.)

However, the Village of Kent lies buried 87 feet beneath this huge body of freshwater. Those who remember the history of the five lost villages will always affectionately know it as Kent Dam. Designed into the structure is a two-lane road 21 feet wide that crosses the 3,200-foot, earth-filled dam. The upstream face of the dam is protected against wave action by light and heavy riprap installed on 12 inches of broken stone. (Author's collection.)

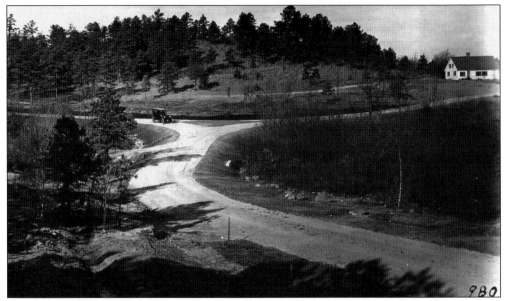

This photograph, taken on November 27, 1917, shows that the location of the new Rockland Cemetery had been determined and construction had already begun. Men would cut the trees down by hand, and teams of horses would pull the stumps out. All cemeteries in the flood area had to be relocated. Each individual grave had to be dug up by pick and shovel then transported here and placed in a new grave that had been dug for a final resting place. The photograph below, taken on June 3, 1918, shows that progress is moving right along. By early summer, the removal of bodies from local cemeteries was well under way.

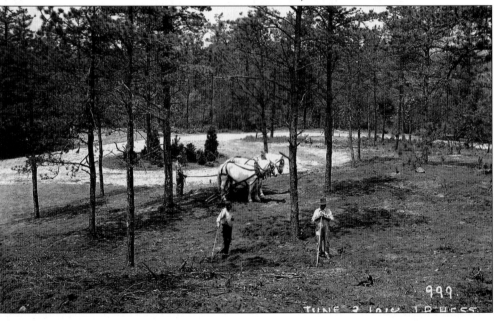

The new Rockland Cemetery is located in Clayville on the Rockland to Clayville Road. It was created for the final resting place of 1,080 of the 1,485 graves that were removed from cemeteries in the immediate area of the reservoir site. The balance of the graves were placed in other local cemeteries. There were 728 lucky ones that remained resting in peace. (Author's collection.)

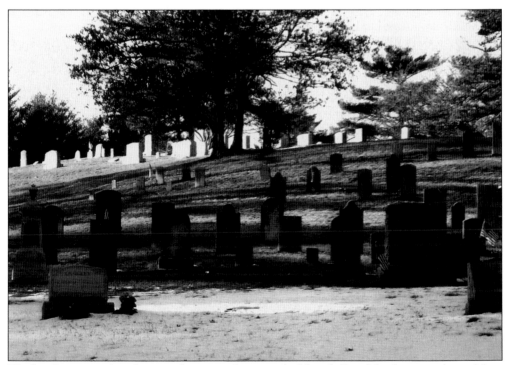

The headstones in this photograph are standing guard of their hill and final resting place of their family and friends. They appear to the photographer as though they have been waiting patiently for someone to tell the story of their beloved lost villages of Scituate. (Author's collection.)

ACROSS AMERICA, PEOPLE ARE DISCOVERING SOMETHING WONDERFUL. THEIR HERITAGE.

Arcadia Publishing is the leading local history publisher in the United States. With more than 3,000 titles in print and hundreds of new titles released every year, Arcadia has extensive specialized experience chronicling the history of communities and celebrating America's hidden stories, bringing to life the people, places, and events from the past. To discover the history of other communities across the nation, please visit:

www.arcadiapublishing.com

Customized search tools allow you to find regional history books about the town where you grew up, the cities where your friends and family live, the town where your parents met, or even that retirement spot you've been dreaming about.